POLKA HEARTLAND

POLKA HEARTLAND

WHY THE MIDWEST LOVES TO POLKA

PHOTOS BY
Dick Blau

WORDS BY
Rick March

WISCONSIN HISTORICAL SOCIETY PRESS

Published by the Wisconsin Historical Society Press
Publishers since 1855

Text © 2015 by the State Historical Society of Wisconsin

For permission to reuse material from *Polka Heartland* (ISBN 978-0-87020-722-8, e-book ISBN 978-0-87020-723-5), please access www.copyright.com or contact the Copyright Clearance Center, Inc. (CCC), 222 Rosewood Drive, Danvers, MA 01923, 978-750-8400. CCC is a not-for-profit organization that provides licenses and registration for a variety of users.

wisconsin history.org

Images, except when otherwise indicated, © 2015 by Dick Blau

Photographs identified with WHi or WHS are from the Society's collections; address requests to reproduce these photos to the Visual Materials Archivist at the Wisconsin Historical Society, 816 State Street, Madison, WI 53706.

The description of the 1986 Ellsworth Polka Festival included in chapter one was adapted from Rick March's "Polka and Tamburitza: Ethnic Music and Dance Traditions in the Upper Midwest," in *Ethnic & Border Music: A Regional Exploration,* ed. Norm Cohen (Westport, CT: Greenwood Press, 2007), 139–140.

Printed in Wisconsin, USA
Designed by Brad Norr Design
19 18 17 16 15 1 2 3 4 5

Library of Congress Cataloging-in-Publication Data
March, Rick.
 Polka heartland : why the Midwest loves to polka / photos by Dick Blau ; words by Rick March.
 pages cm
 Includes bibliographical references and index.
 ISBN 978-0-87020-722-8 (hardcover : alk. paper) — ISBN 978-0-87020-723-5 (e-book)
1. Polka (Dance)—Middle West—History. 2. Polka (Dance)—Social aspects—Middle West—History. 3. Middle West—Social life and customs. I. Blau, Dick, 1943– ill. II. Title.
 GV1796.P55M37 2015
 793.3—dc23
 2015000744

∞ The paper used in this publication meets the minimum requirements of the American National Standard for Information Sciences—Permanence of Paper for Printed Library Materials, ANSI Z39.48–1992.

To Tom Bamberger
—Dick Blau

To Karl, who took me riding on his band bus
right into the heart of the polka world
—Rick March

CONTENTS

♪ *image galleries included*

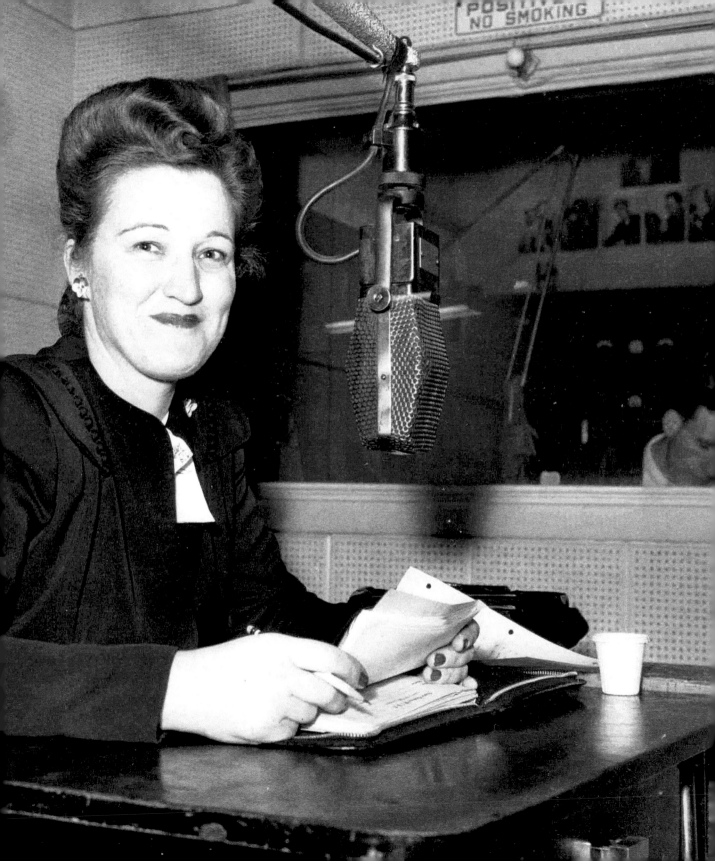

INTRODUCTION

My aunt Agnes
Daniels, host of *The
Croatian Radio Hour*
on WJBK in Detroit
in the 1940s
Personal collection
of Rick March

can't remember the first time I heard a polka. It must have been when I was a baby, because I was born just a few months before Frankie Yankovic's hit record "Just Because" had the nation's toes tapping in 1948. I was only a little boy when, to the lilt of accordions at the Croatian hall, I heard my free-spirited Aunt Agnes chant, "Just because you think you're so *lijepa,* Just because you think you're so *vruća,*" embellishing every line of Yankovic's song with a word or two in our language. She was making the song truly ours, something from our own in-group; and now to our delight, it was a national hit by a big new star. Frankie Yankovic was known to everyone in America, a guy whose Slavic name clearly made him one of us.

My Croatian mother and her siblings had arrived in the United States twenty-five years earlier. For decades, their immigrant community was castigated as "dumb Hunkies." But in 1948 World War II recently had been won, and my relatives felt a new degree of acceptance in American society. They were proud to have contributed to the Allies' victory.

"We worked hard and we fought hard on all fronts," my Auntie Aggie intoned over the radio, speaking of her community. She was the on-air hostess of *The Croatian Radio Hour* on WJBK in Detroit. She interspersed Slovenian polkas by the likes of Yankovic, Tony Omerzel, and Kenny Bass with Croatian tamburitza music.

Slovenia was the neighboring country to the northwest of our old homeland Croatia, and Slovenian Americans often were literally our next-door neighbors in the industrial working-class cities of the Midwest. It was far from unusual for Slovenians and Croatians to attend the same churches, frequent the same bars, and carry their lunch buckets to the same factories. Slovenians, too, were rebuked as "Hunkies." Then came Frankie Yankovic, a proud "dumb Hunky" who had the talent and the smarts

to create a modernized, Americanized version of his ancestors' traditional music and turn it into a big seller on the American hit parade.

When I was a young man living in Milwaukee's south side Polish neighborhood, I discovered that several of the corner taverns featured little polka bands—modest duos consisting of a Chemnitzer concertina and a drum set. Dave Stolowski, Stan Nowicki, and Al Gostomski Roberts were some of these skillful concertina players. One bar, the Plaza, featured bigger Polish bands, including Chicago's Eddie Blazonczyk and the Versatones, perhaps the most influential Polish American polka band ever. Veterans Park, down near the airport, consistently booked an array of the best Polish polka bands from the Windy City.

The young concertina virtuoso Don Gralak lived a few blocks from me, and we became chummy. Don had created a unique amalgamation of Polish concertina and Slovenian polka. Thanks to Don, I learned that in addition to the Slovenian and Polish polkas popular in Milwaukee, there were bands playing even more varieties of polka just a short drive from the city. I was immediately intrigued.

Soon I became a regular listener of WTKM, a radio station in Hartford, Wisconsin, that billed itself as "The Polka Place." Their DJs emphasized the so-called Dutchman and Bohemian styles.

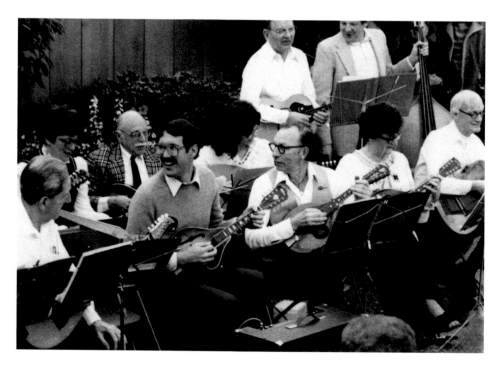

The Blue Danube Orchestra playing in Milwaukee in the early 1980s. I'm in the first row, second from left.

Personal collection of Rick March

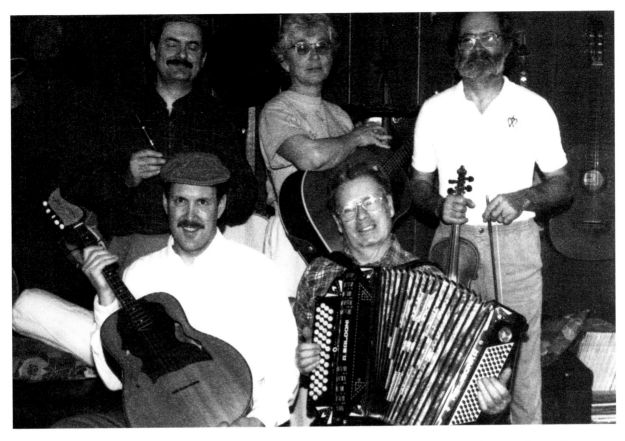

I played with the Madison-based Emerald Isle Ceili Band throughout the 1990s. Top row: Mike Doran, Barbara James, and Joe Lawrence; bottom row: Rick March and Tommy McDermott

Personal collection of Rick March

I discovered how friendly and approachable people on the polka scene could be. I met dancers like Ken and Carol Roth, who taught polka dancing at Veterans Park. Even the big-name musicians proved highly accessible. I became acquainted with Eddie Blazonczyk and Louie Bashell, Milwaukee's most prominent Slovenian bandleader.

Although I am a musician and had become enthusiastic about polka, I was slow to begin performing polka music myself. During my teenage years in California, I had become a folk, blues, and rock musician. Later, in Milwaukee, I played in Blue Danube, a small orchestra that performed Eastern European music on mandolins and tamburitzas. My plunge into playing polka came in 1983, after I relocated seventy-five miles west to Madison to take the job of folk arts specialist for the Wisconsin Arts Board.

Before I had a chance to establish a new network of musician friends, I played solo. But playing the mandolin by yourself isn't so fulfilling. So I picked up a little

A 1964 record cover
from the Goose
Island Ramblers.
Pictured from left:
George Gilbertsen,
Bruce Bollerud,
and K. Wendell
"Wendy" Whitford
Courtesy of
Cuca Records

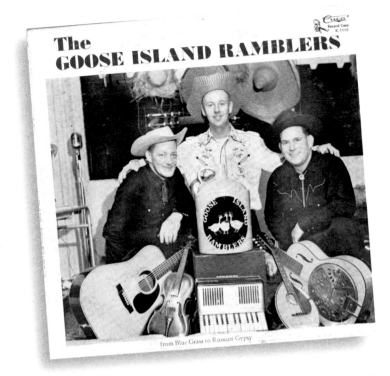

two-row button accordion at a used-instruments shop and taught myself to play. With chords and bass notes on the left hand and melody and harmony on the right, I became sufficient unto myself.

A couple of months later, I received a phone call from Francis McMahan, the former leader of a prominent local old-time dance band. He heard I could play accordion. Francis needed an accordionist for his Irish band. I told him I had never played Irish music. "That's OK," Francis said, "we'll show you." I wound up playing with his Emerald Isle Ceili Band for a dozen years.

This connection proved to be my entry point into the Madison old-time music scene, a broad, multiethnic community of eclectic traditional musicians who had amalgamated several influences to concoct "polkabilly." Years later, my friend and colleague Jim Leary promoted this semi-ironic conflation of polka and hillbilly when he made it the title of his 2006 book about the genre.

Through the Irish band, I reconnected with members of the Goose Island Ramblers: fiddler George Gilbertsen, accordionist Bruce Bollerud, and guitarist K. Wendell Whitford. I first met the Ramblers as a teenager in the mid-1960s when my older brother Bob, a banjo-playing University of Wisconsin physics professor, smuggled me into Glen and Ann's bar on Johnson Street for the Ramblers'

Friday night gig. When we reconnected in the 1980s, I worked with the Arts Board to drum up some renewed performance, recording, and media opportunities for the Ramblers.

Over the years, my Arts Board job afforded me the chance to work with other Wisconsin musicians, too. Many times I was able to recommend bands for national and regional festivals and documentaries for public television. I took a group of polka musicians to Japan to perform in the cultural exchange between Wisconsin and its Japanese sister-state Chiba Prefecture. With their splendid talents, the polka performers made me look good just for recommending them. They consistently were able to do more for me than I did for them.

During my second year with the Arts Board, I became the DJ of a weekly polka program on WORT, Madison's community radio station. I named the show *Down Home Dairyland*. A year later, I took the program statewide every Sunday evening on Wisconsin Public Radio. *Down Home Dairyland* ran from 1984 to 2000.

During the first five years, folklorist Jim Leary joined me as cohost and coproducer.

As a DJ, I occupied a rewarding and well-understood role in the polka scene. I attended dances and polka festivals where bandleaders often pressed promotional copies of their recordings into my hands. Listeners contacted me with requests or to tell me about new musicians.

Whatever the satisfaction my media work has brought me, I have been even more pleased at the opportunities I have had to play polka music, to work as a sideman on banjo or accordion, and to establish my own modest group, the Down Home Dairyland Band.

Through my long immersion in the polka scene, I've picked up knowledge about it that I ought to share. In the early chapters of this book, I explore the history of polka; and in the latter chapters, I bring readers along on trips to polka events that

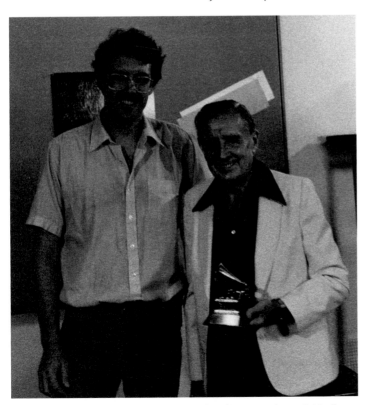

I visited with Frankie Yankovic in 1987 when he came through Madison. Here he's holding the Grammy he won in 1986—the first year polka was a category. Personal collection of Rick March

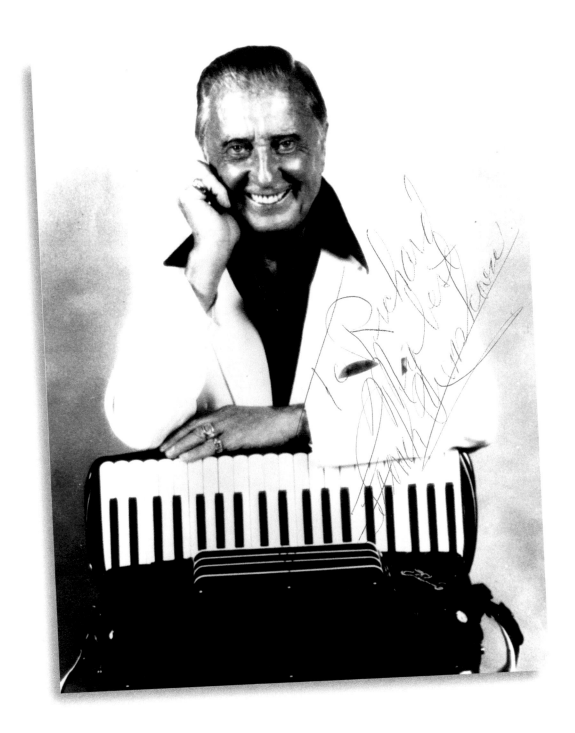

This autographed promotional photo from Frankie Yankovic is a memento of our meeting. Unpretentious and approachable, the "Polka King" had a common touch. I remember Frankie chatting with my older relatives when I was a boy. Years later, he helped in my efforts to validate polka as a midwestern cultural legacy. Personal collection of Rick March

photographer Dick Blau and I undertook throughout 2013—word pictures to augment the impressive photos Dick has captured.

Dick Blau and I have been acquainted for decades. I knew Dick as the photographer who ably captured the spirit of the polka scene beginning in the 1970s, when he collaborated with ethnomusicologist Charles Keil on their pioneering book, *Polka Happiness*. In the midst of feverish activity, Dick has an eye for spotting a telling instant. Dick is a tall guy, like me, but nonetheless he has the ability to insinuate himself and his camera unthreateningly into people's tight spaces to capture their feelings. I thought we would make a good team. Despite our friendship and common interests, somehow we hadn't had a chance to work together until at last the opportunity arose to create this book. Dick was anxious to re-enter the polka world, and I knew the paths.

Inevitably, there are limits to any one book. That means many significant polka locales, musicians, and organizations will be left out. We hope more writers will be inspired to write about the polka.

Throughout this book, Dick and I aim for in-depth, visually oriented views into the active polka scenes of our region. It's an undertaking we don't take lightly. For polka is danced and played a lot, but its story is seldom written.

Polka Heartland

Opposite
(left) Concertina Millie playing at Martin's Tap in New Berlin, Wisconsin; (right) Les Schneider, saxophone player for the Carl Laack Orchestra

Pages 10–11
(left) Stephanie Pietrzak playing the concertina at Pulaski Polka Days; (right) young dancers at Amerahn's Ballroom in Kewaskum, Wisconsin

Pages 12–13
(left) Pam Scesniak, Linda Mueller, and Chanel le Meaux of the Squeezettes, performing at the Milwaukee Beer Hall; (right) Chanel le Meaux

Pages 14–15
Dancers performing the circle two-step at Turner Hall in Monroe, Wisconsin

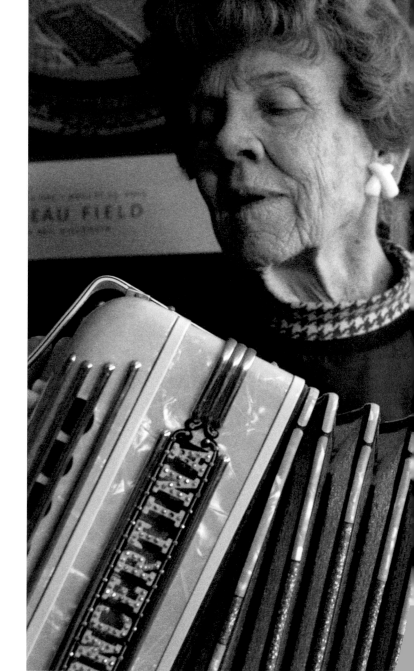

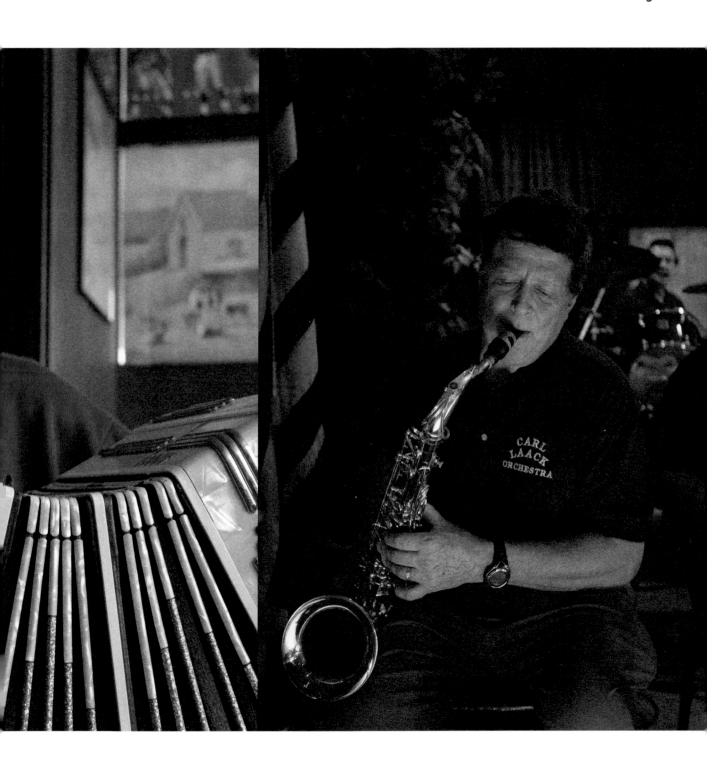

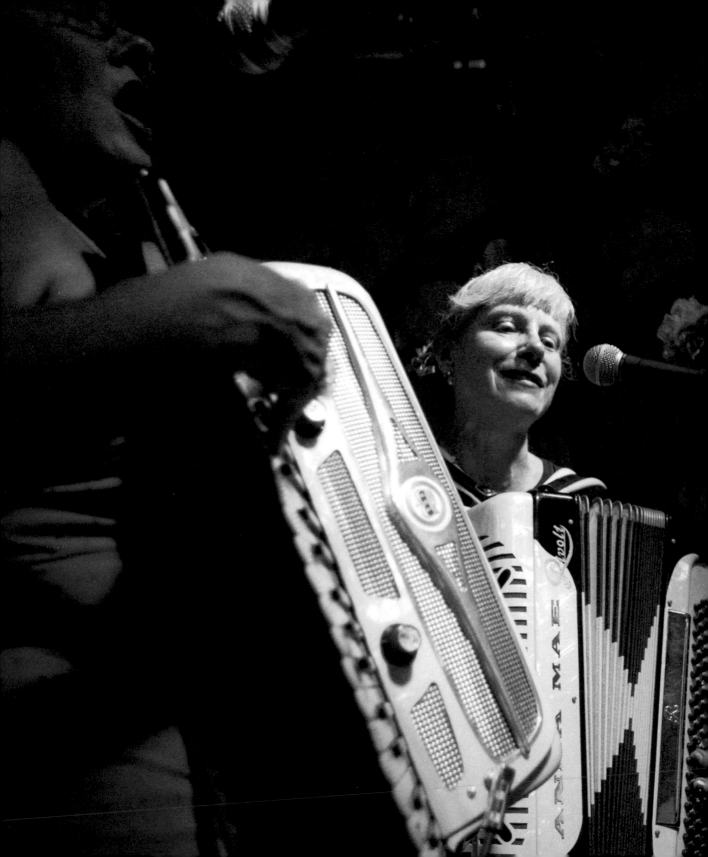

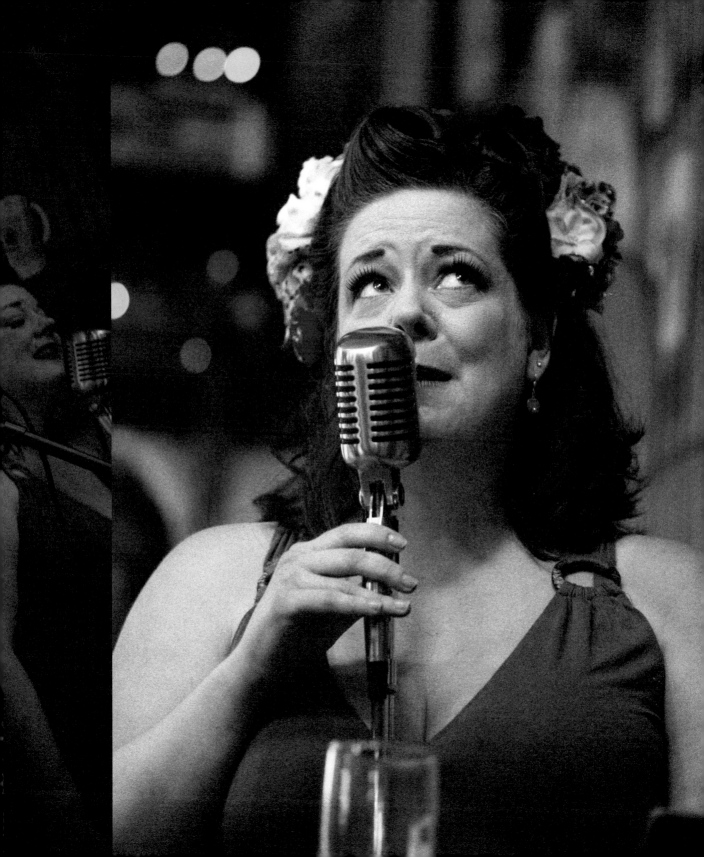

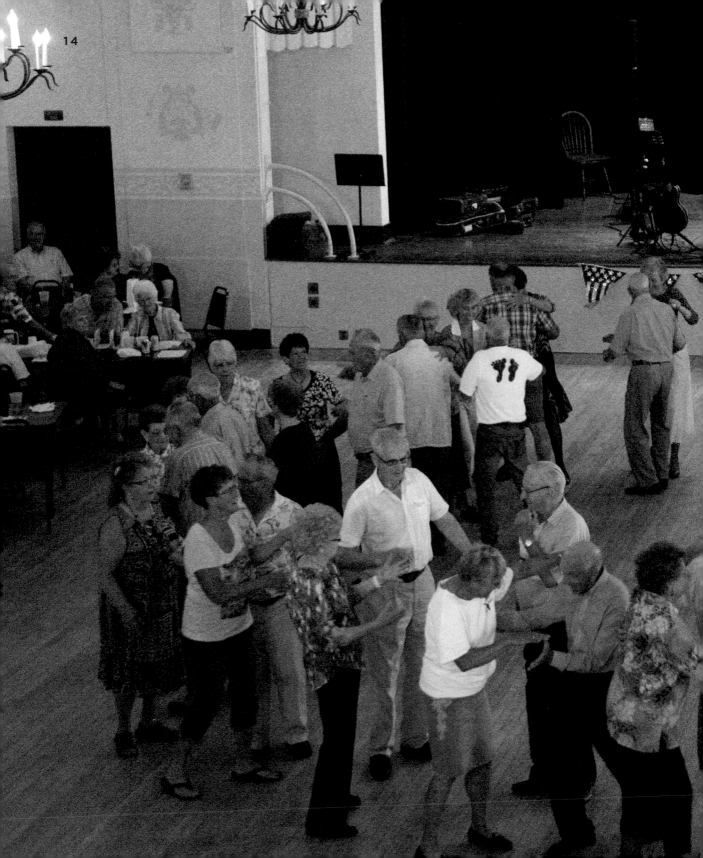

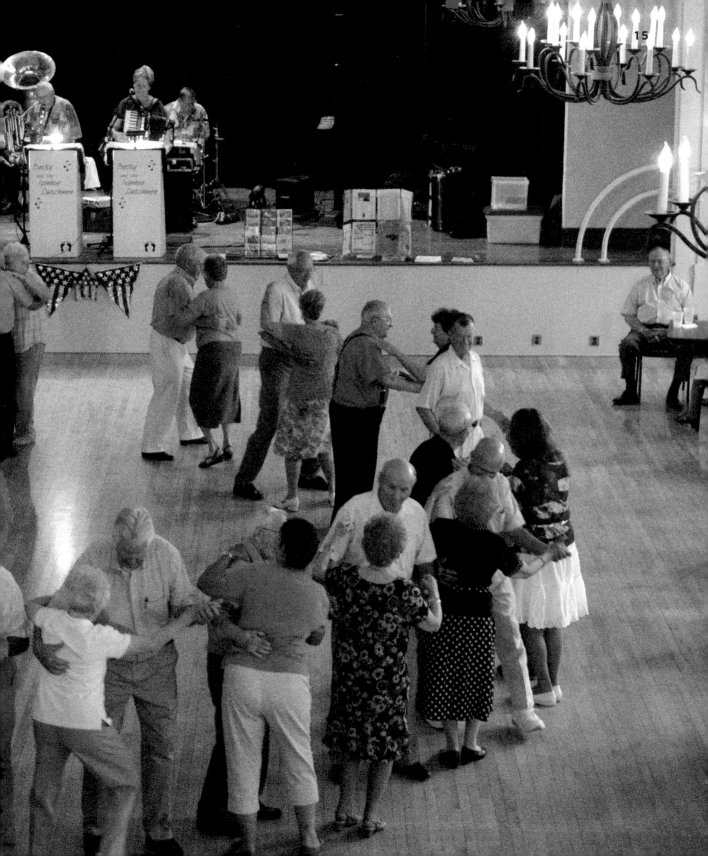

A POLKA PRELUDE

I have an especially fond memory of visiting the Ellsworth Polka Festival in 1986. Lured by the prospect of dancing to some of the best polka bands in Wisconsin and Minnesota, a couple of friends and I made the long drive from Madison to the little town of Ellsworth, in northwestern Wisconsin.

After a few hours of passing through verdant hay and corn fields, we arrived at the festival grounds on the outskirts of town, where big tents had sprouted like gigantic striped mushrooms on the grassy knolls. The hot July air was heavy with humidity, and the smoky aroma of grilled bratwurst and burgers wafted over from an impromptu village of campers and RVs. We left our car on a hay field serving as a parking lot and trudged downhill toward the tents.

From a distance, the polka music streaming from the two dance tents seemed to blend into a single, unruly musical mélange. Even in this cacophonous form, I could make out the madcap, rollicking sense of the music: drums tapping like a fervent heartbeat; tubas bouncing like circus elephants; trumpets, saxophones, and clarinets blending in chorus to form a single, rich-textured voice.

But most of all, I could hear the concertinas, the premier instrument in the Dutchman polka bands, those big, rectangular squeezeboxes with the buttons on the sides. They made a mellow croon on the low notes and chimed on their high notes like musical toys.

At a folding table we paid a small admission fee and were fitted with yarn wristbands, and then we headed for the nearest tent. As we approached, the sounds of Karl and the Country Dutchmen began to drown out the music from the other tent.

Back then, the concertina player Karl Hartwich was still a lanky farm boy from western Illinois. Onstage at the far end of the tent, he was making the reeds cluck

A Star brand concertina played by Craig Ebel, bandleader of the Minneapolis-based polka band DyVersaCo

The cover for the Smithsonian Folkways' *Deep Polka* album features dancers doing the circle schottische at the Ellsworth Polka Fest in Ellsworth, Wisconsin, in the mid-1980s.

Courtesy of Smithsonian Folkways Recordings

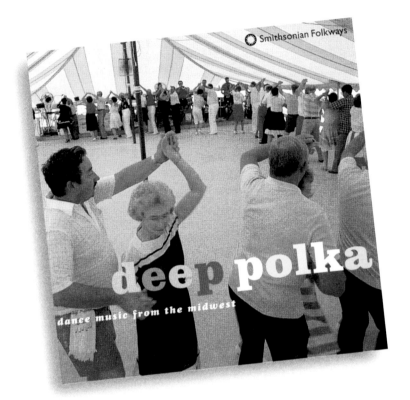

contentedly on one of his showcase tunes, "The Chicken Polka." His casual dress—cutoff jeans, a T-shirt, and clod-hopper boots—belied his absolute seriousness about the music. His functional, no-aesthetic clothes made the point that his music itself was the main thing. Despite the absence of any show-biz trappings, like band uniforms or decorated bandstands, Karl commanded our attention as he pushed and pulled the bellows, the fingers on both of his hands flitting effortlessly over the concertina's buttons. Karl played with infectious gaiety, a straightforward melody, all the while decorating the tune with spectacular, improvised grace notes.

As everyone said, he made the concertina sing.

Moreover, he emanated control of his band. Gesturing with his body language, calling out key changes, and uttering a grunt on a quick break or even letting loose an impassioned barnyard yell on an exhilarating passage, Karl guided his five sidemen to produce the perfect musical complement to his singing concertina. At the same time he worked the crowd, exchanging nods and friendly eye contact with the passing dancers.

We joined the circle of swirling dancers as they spun counterclockwise around the creaking dance floor, which consisted of more than a dozen plywood sheets joined together. The seams were perfectly even; dancers' feet glided smoothly. From time to

time, a festival volunteer strolled the floor between numbers, shaking flakes of floor wax from a cardboard tube onto the plywood.

As is the custom, Karl played three tunes of the same dance tempo: three polkas, then three waltzes, then three fox trots. He occasionally added a set of schottisches or circle two-step mixer dances. In the two- or three-minute pause between sets, dancers returned to their tables to take a quick sip or two on their drinks, but during the music almost everybody was out on the floor.

Some of the dancing couples wore matching outfits, which were often showy and colorful. Some donned uniforms of various polka clubs: green lettering on white shirts for the Wisconsin Polka Boosters, white letters on bright red vests trimmed with rickrack for the Polka Lovers Klub of America, known as PoLKofA. But special polka clothes were far from obligatory. Many dancers wore the sensible, clean work clothing of rural people, suitable for both dancing and doing the milking chores. Indeed, late in the afternoon quite a few of the locals disappeared for a couple of hours to milk their cows.

The dance styles also were far from uniform. The most skilled dancers performed "hop-style" polkas, a newer innovation that originated in the 1960s, danced in double time to the music. When they reached a corner of the floor, the best hop-style dancers stepped out of the rotating circle to execute fancy kicks and jitterbug dance moves that they obviously had rehearsed.

Others glided smoothly left and right, dancing the older, standard polka. Elderly dancers whose mobility had its limits seemed to feel comfortable amid the sea of couples. Even the prancing, athletic dancers were careful not to crash into anyone. At least a quarter of the couples were made up of two women. According to a long-established polka custom, women didn't need to wait for a man to ask them to dance. Several more couples were parents or grandparents dancing with children, some carrying the toddlers in their arms, spinning to the music. The pleasant warmth of a friendly, multigenerational community pervaded the dance floor.

The dance party continued into the early evening. Later, as Brian and the Mississippi Valley Dutchmen were playing up a storm, an actual storm blew up, a real gully-washer. The skies darkened as thunderheads raced over, streaks of lightning and deafening claps of thunder releasing the big drops of rain that the heavy air had promised all day.

Brian and the band played more wildly than ever; someone hollered an ironic request for "Rain Rain Polka," a popular standard. A few of us stopped dancing just long enough to roll down the sides of the tent. While sheets of rain slapped the canvas, we danced on in the faint glow of a few bare incandescent lightbulbs. Now we danced

In its heyday, polka inspired dancers to flock to the dance halls in droves. This photograph of Green Bay's Riverside Ballroom was used on an early-1960s record cover for the Joe Karman Band.
Courtesy of Cuca Records

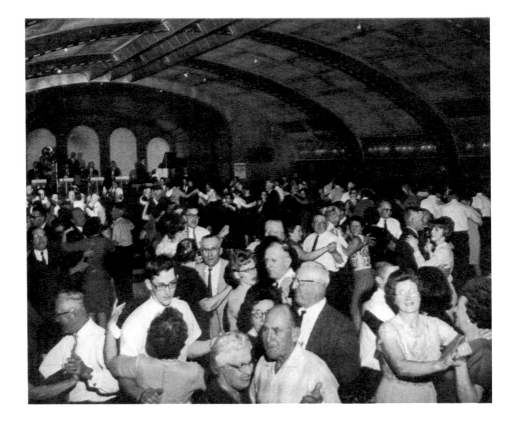

circle two-steps (mixers that reminded us that we were all in this mess together) with gleeful abandon, as if the world outside could be floating away, but inside the tent our circling musical universe could go on forever.

The crucial element in the world of polka is the sense of community that was so graphically emphasized as our dance party at the Ellsworth Polka Festival carried on, sheltered in the big tent from the tempest outside. Polka people go to dances for a number of reasons: for exercise, for a family outing, for the chance to display their best dance moves. But the most important thing is to be under the figurative and sometimes literal big tent, to see and interact with their polka-loving friends. It's a friendly environment where polka people profess their ardor for the happiness that a polka dance engenders. "Polka people are happy people" is a cliché you'll hear frequently from this crowd. "Polka music is happy music." Even when a polka band plays its adaptation of a "cryin' in your beer" country song, the open-throated, straightforward vocals in the polka rendition convey none of the pain and angst typical in a country singer's voice.

In a couple of his original songs, accordionist Gordon Hartmann expresses what it is all about: "Let's whip this party into a polka friendzy . . . good friends and polka music all around."[1] His alternative spelling of *frenzy* is deliberate. "Polkaholic" is another song by Hartmann in which polka transforms a dependence, something that might be taken for a malevolent manifestation, into a benign and even constructive one. He croons, "I need a polka to get me through the day," attesting to the addictive but benevolent influence of polka. At polka dances, as the "friendzy" builds, it is common to see couples whose facial expressions clearly convey they have been transported into a state of bliss.

There are very few indifferent practitioners of polka. If someone says, "Oh, I might dance a polka or two every now and then; I can take it or leave it" that is not a real polka person talking. In the 1940s and 1950s, the era of the polka's greatest popularity in mainstream American popular music, there might have been more of these casual fans. But for the past half century, polka has been scorned by sophisticates as the most uncool idiom in American culture. Nowadays those who choose to persist in their devotion to polka are almost always committed and passionate about it. As members

Fans entering the International Polka Association's 1976 bicentennial festival and convention in Milwaukee

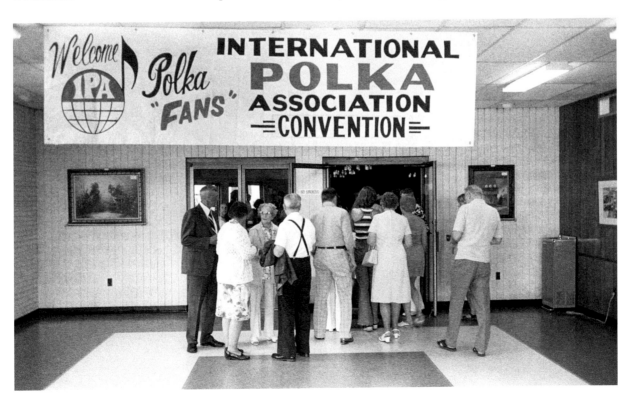

of an often-mocked in-group, albeit one that is welcoming to all comers, polka people know that despite the mockery, they hold the secret to "polka happiness."

Polka people participate in the polka scene in various ways. They might be a fan of a particular band and follow them to as many gigs as possible. They might belong to an informal or official fan club and even sport a shirt or vest identifying themselves as a member. Or they might become a habitué of a particular dance venue, usually a ballroom or a tavern where polka bands play on a regular rotation.

Devoted dancers may join an organized dance club like the Wisconsin Polka Boosters, the We Love to Dance Club, the Happy Hoppers, or the Polka Lovers Klub of America. These clubs organize dances and festivals, often wear uniforms, and make group bus trips to polka events.

The biggest events are the festivals, staged by dance clubs, ballroom operators, organizations such as the International Polka Association, and other types of polka promoters. Polka festivals can last for three or four days and usually feature at least two dance floors with simultaneous performances from different bands.

Over the past three or four decades, it has become increasingly uncommon to find polka music at most corner bars or rural crossroads taverns. So the polka festivals have emerged as the number one place to polka. Thousands of polka enthusiasts have become followers on the polka festival circuit. During the warmer months across the

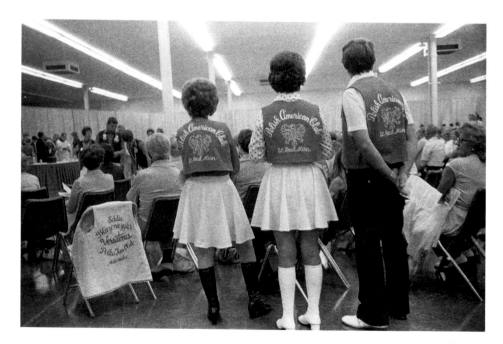

Fans at the 1976 IPA convention show off their polka club outfits.

Midwest, at least one polka festival takes place every weekend, and the winter gloom is brightened by a few January or February polka fests, too. Scores of retirees travel from festival to festival, often camping in festival-provided sites in their RVs or camper trailers. This mobile polka community has become their emotive home.

Membership in a particular polka community may be determined by ethnicity. For example, people with Polish heritage may frequent the so-called Pol-Am dances, although it's also possible to be an enthusiast for a popular polka style from a different ethnic heritage. For example, plenty of Norwegian Americans in Minnesota and western Wisconsin are big fans of the Dutchman bands in their area even without German ancestry.

Nowadays, polka dancers in most areas are an aging population, with the notable exception of the many younger Polish and Mexican American polka enthusiasts. At most polka venues, I see more gray hair and considerably fewer people on the dance floor than what I recall from a couple of decades ago. Nonetheless, polka is unlikely to become completely extinct. Although fewer in number than their elders, young musicians and new polka people continue to join the genre, 175 years after the first polka craze hit Europe. This nineteenth-century dance has had a long run, and it doesn't appear to be over yet.

Polka music and dance have become symbolic of regional identity. In cities like Milwaukee and Cleveland, polka bands play to younger brew-pub audiences. They may not be skillful dancers, but after downing a few beers, the young crowds enthusiastically jump around to a polka beat.

At the Green Bay Packers home games in Green Bay, Wisconsin, the entire grandstand is known to burst into song, singing the old Polka standard, "Roll Out the Barrel." In freezing December weather, Packers fans in green-and-gold coats dance the polka at tailgate parties in the parking lot. The University of Wisconsin's Badger Band includes polkas in its repertoire. The tuba section circles the field during the third quarter, playing an all-tuba version of "Beer Barrel Polka." After the game, the band returns to the field, win or lose, for the "fifth quarter," when the cheerleaders excitedly polka to the "Bud Song," a polka melody the Badger Band played for an Anheuser-Busch TV commercial in the 1970s, which is now a Badger Band tradition.

Thus the polka scene is a landscape of distinct but overlapping small and bigger communities. In this book, Dick Blau and I explore several of them. Working from our own homes in southern Wisconsin, in Milwaukee and Madison, we visited the rich polka scenes that are close to home and discuss other polka strongholds farther afield.

Although the polka has risen and fallen in overall popularity in the wider circles of society, for its devotees the polka remains today, as it was called back in 1844 in the *Kentish Gazette,* "quite a favourite, and is loudly called for every evening."[2]

THE ORIGIN STORY

Polkas have been played by hundreds of bands all over the United States in a dizzying array of ethnic styles. The polka is a tradition in most European countries and is incredibly popular in several Latin American nations, too.

The dance turns up in unexpected locations. Native people of the Tohono O'odham tribe in southern Arizona play polkas in a hybrid style they call "chicken scratch."[3] The polka *sa nayon*, which means "polka in the village," is danced in the Tagalog region of the Philippine Islands.[4] Symphony orchestras play polkas composed by the likes of Johannes Brahms, Johann Strauss, and Franz Liszt.

With so many musical ensembles in so many places around the world playing so many varieties of polka, it is natural to ask the question, "Where did it start? Where did this music and dance come from?"

For answers we have to look back more than a century and a half.

Plenty of evidence suggests the polka emerged in the 1840s as a dance fad that rapidly spread throughout Europe and then quickly moved to the Americas. But people tend to want more details, to know exactly where it began. Articles, encyclopedias, and the Internet offer a fairly consistent origin story for the polka. Yet there are competing explanations over the original meaning of the word, over when and where and by whom the polka was first danced, and who specifically is responsible for its rapid spread.

Researching polka's history, I found numerous versions of the familiar story of polka's origins. Each variant offers its own twist, but certain key elements persist: In the 1830s, in any of a few named locations in the area of the Habsburg Empire where today the Czech, Polish, and German borders converge, a servant girl, who is sometimes Czech and sometimes Polish, demonstrates to her employer, who is sometimes a schoolteacher, a doctor, or some other learned person (though in all versions he is a

Tuba player Mike Chaltry of the Squeezettes, performing at the Milwaukee Beer Hall

When it first appeared, the polka scandalized high society by the way couples danced so closely together. This illustration of a London dance appeared in a novel titled *Mrs. Perkin's Ball*, published in London in 1847.

Courtesy of UW-Madison Libraries, Special Collections

man), a dance that she has invented. He observes her, writes down what he sees, and disseminates it to the world.

The name *polka* is given to the dance, variously interpreted as referring to the word for "Polish woman" (*polka*), or, as others contend, deriving from a Slavic word for "half" (*pol,* or *púlka*), supposedly in reference to half-steps or half-beats in the dance motions or rhythms.[5]

Polka's origin story relies on a wealth of detail to sound as convincing as possible. One source cites Hradec Kralove in Bohemia as the town of origin. Others claim, and popular versions seem to favor, another Bohemian village, Labska Tynica, and there the servant girl has a name. She is Anna Slezakova (nee Chadhimova) who, according to a popular version, danced the very first polka at three o'clock on a Sunday afternoon in 1834.[6] However, other authorities claim the dance was mentioned even before 1830 and do their best to debunk this widespread story.[7]

With so many varying opinions, who is right? Well, no one, actually.

If our concern is historical veracity, the origin stories all come up deficient. The sources of the information are obscure, usually not cited, and often unreliable. Moreover, the basic story seems unlikely. A single person demonstrates a couple's dance. Then it is "written down." Did this rural schoolteacher happen to know dance notation? And were there enough people who could read that notation and become excited enough to begin a dance craze?

Rather than an accurate history, the story sounds like Romantic-era hype used to promote polka as the popular fad it had become. Romanticism had emerged as a literary, artistic, and intellectual movement in Europe in the late eighteenth century, and in typical Romantic-era style, intellectuals of the day were fascinated by all things related to the peasantry.

Therefore, connecting the polka to peasant origins would have appealed to Romantic-era intellectuals, who were infatuated with the idea of peasant culture but had little knowledge of actual peasants and their ways. The underlying hierarchical notions that would have been typical of the thinking of Austria's intellectual class are firmly embedded in the polka origin story. The writers who spread the legend ascribed polka's origin to the romanticized peasants, specifically a lowly, illiterate Slavic servant girl. Then the dance was culturally "elevated" by a member of their empowered class, her employer, an educated Germanic male who establishes polka's significance by rendering it into a fixed written form.

Moreover, the common assertion that a Czech girl in Bohemia "invented" the polka owes much to the nationalist dimension of Romanticism. It was important to nineteenth-century Czech nationalists to assert the purely Czech peasant origin of this suddenly popular dance. Polka arose in Bohemia. Czech nationalists argued that it resembled earlier Bohemian folk dances. To counter any possible claims of Polish origin, they rejected the "Polish woman" meaning of *polka* in favor of the *"púlka"* half steps or half beats etymology.[8]

In fact, no one can show a specific central European peasant dance that clearly is the antecedent of the polka. Pre-nineteenth-century peasant dances were overwhelmingly performed in lines or circles, not in couples. The basic step of the polka is simple and has room for considerable variation. Thus there is no single step from a peasant line dance that convincingly can be shown as the true source of polka.

There was, however, an earlier dance that burst upon the scene in Europe in similar circumstances. The courtly waltz, which came into vogue in the 1780s, seems to be a much more likely model for the polka. It's common for a new form of popular culture to spring from an earlier form. In its era, the waltz craze shocked conservative sensibilities, just as the polka would do years later. The waltz's 3/4 time signature bore resemblance to the Austrian village music for a dance called the ländler. But peasants stomped and clomped out ländlers, while in urban Vienna, couples transformed the dance into the smooth, gliding waltz.

The waltz was the first couple's dance to become widespread in Europe.[9] Johann Strauss's compositions spread its fame.[10] As society became more urban, the communal nature of the village line or circle dance seemed archaic. These were replaced with

couple's dances, which emphasized the importance of the nuclear family instead of the village commune in the industrial and mercantile society that was emerging.

The waltz stretched the conventional mores of its time. Even the famed English poet Lord Byron, generally considered a free spirit, lambasted the "not too lawfully begotten 'Waltz'" in one of his poems. He decried it as a vulgar, seductive, undesirable import to England that came along with the imported Germanic royals:

> Drawn from the stem of each Teutonic stud:
> Who sent us—so be pardoned all her faults—
> A dozen dukes, some kings, a Queen—and Waltz.[11]

The waltz was nothing like the refined dances that had preceded it in elite society, such as the quadrille and minuets, which according to a nostalgic account by an anonymous high-society dame in 1853 in *Blackwood's Magazine*, "admitted of a slight and tremulous pressure of the hand—nothing more—between parties ripe for declaration."[12]

In the waltz, however, a man and a woman danced with arms around each other, gliding across the floor at a comfortable tempo in a relaxed $3/4$ time signature. Such intimate dancing was considered outright licentious by some. "No father of a family . . . can rejoice in seeing his daughter's waist spanned by the arm of some deboshed dragoon," wrote the same woman in *Blackwood's Magazine*.[13]

But, by the 1840s, the waltz had managed to achieve acceptance in society ballrooms. As the waltz lost its shock value, along came the polka and the galop, dances in which couples whirling in each other's arms now hopped frenetically to a spritely, rapid tempo in $2/4$ time.

This sent our high-society dame completely over the top. Referring to the Roman legend in which Romulus, the founder of Rome, and his male followers abducted brides from the Sabines, a neighboring tribe, she decried the fast couple's dances:

> You saw an infuriated-looking fellow throw his arm around a girl's waist, and rush off with her as if he had been one of the troop of Romulus abducting a reluctant Sabine. Sabina however, made no remonstrance but went along with him quite cordially. They pursued a species of bat-like race around the room—jerking, flitting, backing and pirouetting, without rule, and without any vestige of grace, until breath failed them, and the panting virgin was pulled up short on the arm of her perspiring partner.[14]

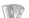

With such power to outrage the upper crust, it's no wonder polka was embraced not only by young members of the elite but also, for their own reasons, by the middle and working classes, too. In a time of social change, commoners relished an opportunity to taunt the aristocracy. By dancing the polka, the non-elites of the 1840s were defying the customs and rules set by the waning aristocracy that still repressed them. At the time, revolutionary tides were swelling throughout Europe, and the polka was a dance to express rebellion, self-validation, and liberty in the burgeoning, changing industrial society.

Thus, it seems the polka fad emerged simultaneously among the middle and working classes and as a vogue trend in elite ballrooms. The best evidence indicates the fad likely began in Prague in 1835, spread to nearby Vienna in 1839, and then moved to Paris and London in 1844. Everywhere it appeared, the dance was rapidly embraced.[15]

An illustration of a Parisian ball, from an 1867 issue of *Harper's Weekly*
Harper's Weekly

It seems polka was introduced to England's elite from French sources. A June 1844 article in the *London Standard* noted an upcoming occasion where "Madame Albert and Mademoiselle Forgeot will introduce the celebrated polka dance."[16] But accounts in the English and Scottish provincial press indicate its penetration was not limited to urban London but was broad from the start. A July 1844 article in the *Ayr* (Scotland) *Advertiser*, published in a small town quite a distance from London, characterized the polka fad as a "dancing epidemic."[17]

The September 28, 1844, *Leicestershire Mercury* and a few subsequent issues of that paper featured an advertisement offering an opportunity to learn "La Polka Dance in 8 lessons for Half-a-Guinea" at the Assembly Room in Humberstone, Guernsey.[18] And before long, the polka's English detractors were raising their voices in locations far from London. An article in the September 1847 issue of the *Manchester Courier* titled, "On the Degrading and Immoral Tendency of the Polka Dance," decried "the polka danced in its greatest impurity."[19]

In spite of its detractors, the polka also had powerful supporters. In 1846, the famed author Charles Dickens noted with approval that "the common people waltzed and polka'd without cessation to the music of the band." Dickens, an influential voice for the welfare of the British lower classes, was so enamored of the polka, that, in a reminiscence written by his daughter Mamie in *Youth Companion,* she recalls he prevailed upon his daughters to teach him and his friend John Leach, the editor of the popular magazine *Punch,* how to polka. The two men acquitted themselves admirably with their small partners at a Christmas season Twelfth Night party.

"As in everything he undertook, so in this instance, did Charles Dickens throw himself into the dance . . . ," Mamie wrote. "[He] kept it up as long as was possible, and was [as] unflagging in his dancing and his enthusiasm as was dear old Fezziwig in his."[20]

Polka had truly taken England by storm—a storm that would soon blow across the Atlantic to the United States.

Charles Dickens with his daughters, Kate and Mamie
Courtesy of National Portrait Gallery, London

3

POLKA'S MIGRATION TO AMERICA

I n the 1840s, if the weather was good, it took at least ten days for a message to cross the Atlantic by ship, from England to North America. The polka craze must have been considered a stunning development, given how quickly news traveled to the United States after the European fad emerged.

Polka madness hit Paris and London in March 1844. No more than two months later, on May 2, an advertisement in the *New York Daily Tribune* touted the latest issue of a new weekly newspaper, *The Picture Gallery*. The ad listed the new issue's illustrations, including a "Portrait of James Harper, Mayor-elect of New-York," "Interior of the House of Lords with Queen Victoria on the throne," and, notably, "the music of the celebrated new Parisian 'Polka' dance, accompanied by an illustration."[21]

The polka craze hit New York with blinding speed. On June 4, 1844, the *Tribune* noted that Atwill, "the enterprising proprietor of the Music Repository," just issued sheet music for "the universal Polka Dance."[22] Six days later, on June 10, a *Tribune* writer cited a notice about polka in the latest *London Court Journal* and sardonically commented, "It is of course known to that portion of our readers who delight in 'fashionable intelligence' that a new dance has been introduced [in Europe] called the 'Polka.' . . . It is odd to think that our people have a fashion of imitating all the new follies of Europe."[23]

The very next week, polka was featured in a Broadway show at Niblo's Garden, which attracted New York's middle and better-off working classes, people who could afford the fifty-cent admission charge. The show began with an "*Apropos Bagatelle* entitled POLKA-MANIA!" a strikingly modern-sounding name. The short play had a cast of seven. In the course of the piece, four cast members, two couples, danced "La Polka."[24]

Steve Meisner with his
Baldoni accordion

At the same time, the younger set of wealthy elite embraced the polka craze. An observer noted that during the summer of 1845, at the social dances for the bathers in Newport, Rhode Island, who would have been the youth of New York's elite, the dancers were attempting to hop the polka, and none too gracefully, in his derisive view.[25]

The polka was also accepted by the city's poor. An 1846 news story noted that every "street urchin" was chanting a song, "Won't you dance the polka?"[26]

Polka activity in New York City remained strong through the 1840s, but it seemed to take a few years for the music and dancing to spread to the rest of the country. Between 1850 and 1855, the publishing of polka sheet music spread from New York to Baltimore, Philadelphia, Louisville, Cincinnati, New Orleans, and other cities, and mention of polka dances in regional American newspapers increased.

A sampling of cover illustrations from polka sheet music in the mid-1800s

Library of Congress, American Memory Collection

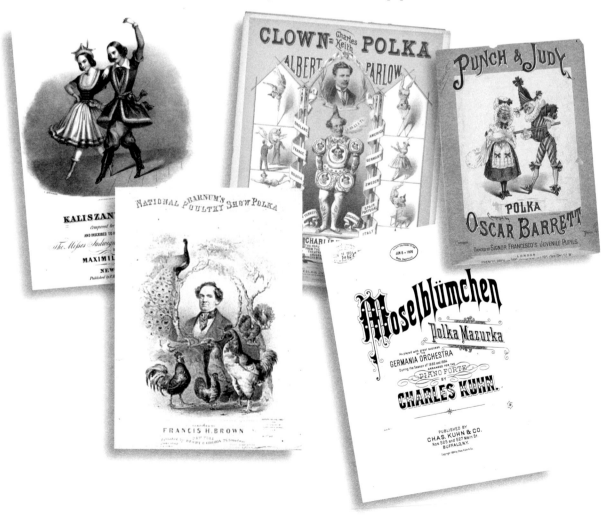

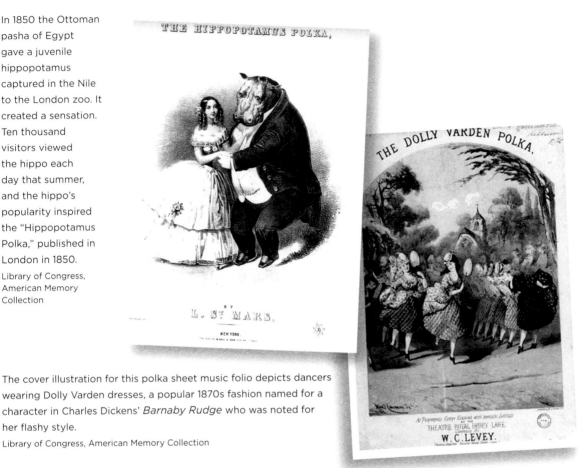

In 1850 the Ottoman pasha of Egypt gave a juvenile hippopotamus captured in the Nile to the London zoo. It created a sensation. Ten thousand visitors viewed the hippo each day that summer, and the hippo's popularity inspired the "Hippopotamus Polka," published in London in 1850. Library of Congress, American Memory Collection

The cover illustration for this polka sheet music folio depicts dancers wearing Dolly Varden dresses, a popular 1870s fashion named for a character in Charles Dickens' *Barnaby Rudge* who was noted for her flashy style. Library of Congress, American Memory Collection

As it spread, the controversy over the dance's decency widened. A writer in the *Lewisburg* (Pennsylvania) *Chronicle* wrote, "The modern imported dances such as the 'Polka' . . . are redolent with the lasciviousness of Paris and Vienna."[27] The prevalence of the dance at elite balls was dampened when, in September 1853, American newspapers widely reported that Queen Victoria had prohibited polka dancing in her presence. No doubt, the queen's consternation only increased the dance's appeal to rebellious youth.

Although the sheet music for polkas was almost exclusively published as instrumental music usually arranged for the "pianoforte" and without lyrics, their titles were evocative of trendy interests of that time. "The Hippodrome Polka," "Electric Polka," and "Barnum's Baby Show Polka" are just a few titles linking polka to the popular culture and modern developments of the day.

As the United States drifted toward civil war, politics came to be reflected in polka titles as well. In 1860 a Boston music publisher issued "Rail Splitter's Polka" to support the presidential campaign of Abraham Lincoln. In the next year, 1861, Southern firms published a spate of polkas dedicated to the Confederate cause—for example, "Southern Rights Polka," published in New Orleans; "Dixie Polka," published in Mobile, Alabama; and "Secession Polka," published in Macon, Georgia, and dedicated to Confederate President Jefferson Davis.

In 1863, to commemorate the defense of Charleston, South Carolina, after a sixty-day US naval siege, a Columbia, South Carolina, music publisher, B. Duncan & Company, issued "Battery Wagner Polka-Mazurka," with a cover lithograph of the cannons and defensive earthworks at Fort Wagner, a key emplacement in Charleston's defense. In a business circular dated July 27, 1863, Duncan wrote, "We have made arrangements to be constantly supplied through the blockade with the latest European Music of merit, and will publish it as soon as received."[28] It seems polkas were among the essentials smuggled into the South.

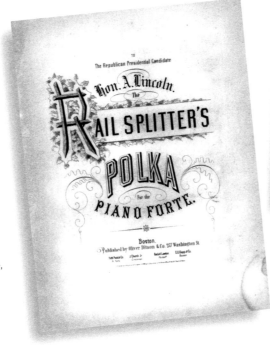

"The Rail Splitter's Polka" was composed for Abraham Lincoln's presidential campaign. Its sheet music, pictured here, was published in Boston in 1860.
Library of Congress, American Memory Collection

"The Battery Wagner Polka-Mazurka" was written in support of the Confederate cause. The sheet music was published in Columbia, South Carolina, in 1863.
Library of Congress, American Memory Collection

Through the 1850s and 1860s, polka music and dance were considered part of mainstream American popular culture, both in the North and in the South. Though it was an import from Europe, the music did not necessarily have any ethnic cultural connections. But with the influx of immigrants coming to the United States from central and eastern Europe through the latter half of the nineteenth century, the polka's unhyphenated "Americanism" began to become diluted. The polka began to be associated especially with German immigrants, its earliest ethnic group association.

Through the latter half of the nineteenth century, immigration to the United States mushroomed. Throughout the 1820s, 152,000 immigrants came to the United States. By the 1840s that number was 1.72 million. Of these, more than 25 percent came from Germany. The 1850s saw even more immigrants from Germany: 952,000 out of a total of 2.6 million, or 37 percent. Immigration in the nineteenth century peaked in the 1880s, with more than 5.2 million immigrants, of whom 28 percent were German.[29]

Many immigrants from Germany settled on midwestern farms. Others lived in larger cities, where they established vibrant communities with German-language newspapers, theaters, and choirs. Ohio River cities like Cincinnati and Louisville developed a strong German imprint, as did St. Louis on the Mississippi. On Lake Michigan, Milwaukee became touted as "the German Athens" for the strong German cultural life established there, and Germans played a big role as skilled workers and entrepreneurs in Chicago's burgeoning industries.

When these immigrants left Europe, the polka was all the rage in their homelands. Those who emigrated in the 1850s and '60s found that polka was already entrenched in the United States. But while mainstream enthusiasm for the polka began to fade across the United States by the 1870s, German and other central European immigrants' devotion to polka remained undiminished. Interestingly, even though it was a recent fad when they left Europe and not an ancient tradition, these immigrants reconceived polka as important to their distinct European heritage. It would be as if a group of Americans migrated to a distant country in 1960 when the twist was the latest dance fad, and then they preserved twisting as an important part of their American cultural legacy for years to come.

Polka's association with Germans continued to grow throughout the nineteenth century. In the 1850s and '60s, the titles of polka sheet music were overwhelmingly in English, with an occasional title in French. "Sontag (Sunday) Polka," published in 1850, was one of the rare German titles. Even a polka tune composed by Max Braun and published by P. K. Weizel in Brooklyn in 1854 was titled only in English as "German Polka." In the 1870s and '80s, however, German titles became more

common, such as "Linden Polka Mazurka," "Blumen Polka," "Tanz Jubel Polka," and "Ueber Stock und Stein" by composers Wm. Schilling, C. M. Ziehrer, A. Baur, and C. Faust, respectively.

As the size of their ethnic group swelled, Germans and their music became a more and more noticeable presence on the American cultural scene, and their cultural habits sometimes sparked conflict with their fellow citizens. For example, in Chicago in 1858, Peter Pecksniff, editor of the *Chicago Times* and a local politician, launched a crusade against "desecration of the Sabbath" by supposedly impious Germans who frequented their "Lagerbeer saloons" and "Polka Kellers" on Sundays.

In response, the writer of a letter to the editor, who signed only as "A German," defended his compatriots' way of life, saying that their concerts and Sunday amusements occurred "in the thoroughly German quarters of the city where, of course, people are accustomed to observe Sunday according to the cherished habits of their fatherland."[30]

He continued, "A man who works hard for six days will have some recreation on the seventh . . . and even if they play an old flute or violin to enjoy the softening art of music . . . what crime is it that they commit by such acts?" The writer added, on a conciliatory note, that the Chicago German newspaper *Staatz Zeitung* advised its readers to moderation in Sunday amusements, particularly in the "Polka Kellers," so as not to offend "Americans."[31]

By the close of the nineteenth century, new immigrants continued to stream through Ellis Island, and the ethnic mosaic became ever more varied. Fast on the heels of the arrival of German immigrants came the Czechs, a famously polka-loving people who have contributed so much to the creation and dissemination of music. There followed other polka enthusiasts: Swiss, Poles, then Slovenes, Ukrainians, Lithuanians and many other eastern European groups. Italians, Norwegians, Danes, Swedes and Finns, Belgians and Dutch came, too. While they immigrated to many regions, the arriving Europeans chose America's upper Midwest as a prime destination.

By the early twentieth century, the polka had evolved—it was no longer considered a mainstream American music fad but rather the music and dance of still-unassimilated newcomers from Europe. Members of these immigrant communities became the creators and practitioners of the many polka traditions that continue across the US heartland today.

Welcome to Swissconsin

When you approach the village of New Glarus along Wisconsin State Highway 69, the church steeple and picturesque skyline invite comparisons to Europe. New Glarus really feels like a Swiss village. There are no towering Alps, but the forested, rolling hills of Wisconsin's Green County give contours to the landscape that no doubt made the Swiss immigrants feel at least somewhat at home in this part of the mountainless Midwest.

In 1845 a group of almost two hundred Glarners, natives of Glarus Canton in Switzerland, were among the first Europeans to come to Green County. They named their new town after their old homeland. Soon they were joined by more arrivals from Glarus and other Swiss cantons, notably Bern and Appenzell. All around the New Glarus area, Swiss immigrants established dairy farms, mostly choosing to milk the breed with which they were familiar in the Old Country, Brown Swiss cattle.

From the beginning, music was important to the members of Wisconsin's cohesive Swiss colony. The community's first log church was built in 1849, and a minister from the Swiss Reformed Church came over from Europe in 1850. In addition to singing hymns in the church, Swiss immigrants branched out to organize secular choruses.

Immigrants from the Bern and Appenzell regions brought with them their regions' strong yodeling traditions. In 1890, New Glarus residents established a yodel choir, just in time for the community's 1891 celebration of the six hundredth anniversary of Swiss independence.

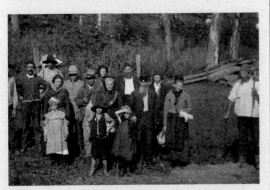

Second-generation Swiss Americans dressed as Swiss immigrants for the sixtieth anniversary of the founding of New Glarus in 1905.
WHi Image ID 42739

POLKA INTERLUDE

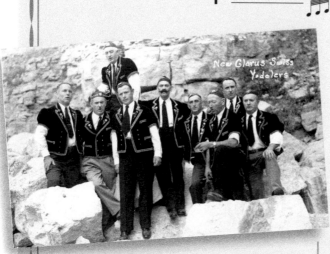

A group of Swiss yodelers from New Glarus, date unknown
WHi Image ID 44005

Wisconsin's Swiss immigrants understood their community's celebrations might be interesting and attractive to other Americans. The 1891 festivity became the first major event to attract tourists to Green County, launching a tourism industry based on the local Swiss culture that continues today and helps fuel the local economy.

Residents here celebrate Volksfest, a Swiss national holiday that features music and flag throwing; the Wilhelm Tell Festival, which includes a community production of Friedrich Schiller's play about the famed Swiss patriot and archer; the Heidi Festival, which involves a staging of Johanna Spyri's play based on the famous Swiss novel; and the Swiss Polkafest, which transforms New Glarus's Main Street into a spacious, tent-sheltered dance floor.

The most common tempos in Swiss music include polkas, waltzes, ländlers, and schottisches, which were brought to these Midwest communities by musicians touring from Europe and by new musical immigrants. In 1925, a pair of famous Bernese yodelers, the Moser Brothers, made their first national tour of the United States and inspired an American yodeling craze. The Moser Brothers played to packed houses and recorded thirty-six songs for Victor Records in New York. Before long, American entertainers had adopted the yodel, too. Most notably, cowboy yodelers such as country music pioneer Jimmie Rodgers, known as the Blue Yodeler, performed Americanized variants of a singing style originated by Swiss herdsmen.

The Moser Brothers were responsible for catapulting the career of a musician who later would become key to Wisconsin's Swiss music scene. Rudy Burkhalter was born in the Swiss city of Basel in 1911. As a child in the early 1920s, Rudy was

POLKA INTERLUDE

considered an accordion prodigy across Switzerland. He won a national contest at age nine, and at age 11 he traveled with his father to Paris to make recordings for Odeon Records. In 1928, when the Moser Brothers needed a reliable accordionist to accompany them on their second American tour, they recruited teenaged Rudy to join them, much to his mother's consternation.[32]

For the next few years, Rudy continued to entertain across Switzerland and made additional American tours with the Mosers. While performing at the 1933 World's

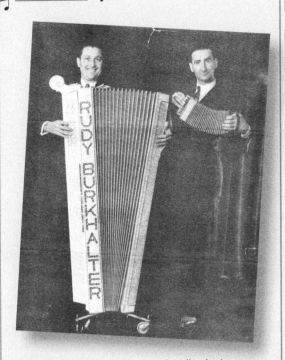

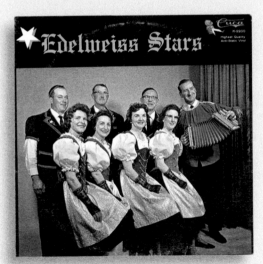

1960s album cover for the New Glarus-based Edelweiss Stars yodel choir, accompanied by Rudy Burkhalter on the accordion
Courtesy of Cuca Records

When the famous North Dakota bandleader Lawrence Welk played in Madison in the 1940s, he often spent time with his friend, the renowned New Glarus accordionist Rudy Burkhalter. Here, they are clowning around, Lawrence posing with Rudy's giant accordion and Rudy posing with one of his tiniest squeezeboxes.
Personal collection of Rick March

Fair in Chicago, Rudy met Frances, a farm girl from Minnesota. They married in 1937 in Switzerland and returned to the United States the following year, settling near Lake Wingra in Madison, a location Rudy had noticed while barnstorming with the Mosers.

POLKA INTERLUDE

New Glarus was less than thirty miles down the road. Soon, Rudy was playing with several local bands, such as the Edelweiss Stars out of New Glarus and the Shamrock Band from Madison. Rudy established an accordion school and traveled each day to towns in a fifty-mile radius of Madison, renting local halls for group lessons. Over the years, he would teach thousands of Wisconsin children. Rudy's most promising students performed on a Sunday afternoon radio program on WIBA in Madison.

As the accordion and the polka enjoyed widespread popularity in the postwar era, Rudy's stature grew. In 1956, he was called upon to provide music and compose a song for the Walt Disney feature "Adventure in Dairyland." Annette Funicello sang Rudy's song, "Teach Me How to Yodel," which has remained a local favorite ever since.

Some of Rudy's students went on to make important contributions to music in southern Wisconsin. New Glarus resident Betty Vetterli became an adept accordionist and a masterful yodeler. When the button-accordionist and singer Martha Bernet emigrated from the Canton of Bern to nearby Monroe, Wisconsin, in 1947, she and Betty teamed up, performing as a duet and becoming stalwarts of the Edelweiss Stars. Martha began broadcasting Swiss and other polka music on local radio station WEKZ in 1951, continuing those efforts for more than fifty years.

Another New Glarus farm kid, Roger Bright, started taking accordion lessons from Rudy and then created his own band at the age of fifteen. By the early 1960s, Roger was touring with Frankie Yankovic and was featured on ten Yankovic albums. It's not surprising that Roger fit right in

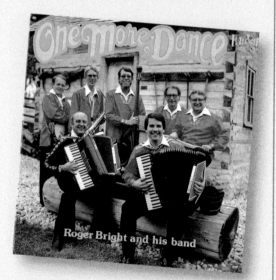

An album cover for Roger Bright and his band, from New Glarus, Wisconsin
Personal collection of Rick March

POLKA INTERLUDE

with Yankovic's Slovenian-style polka, as Swiss and Slovenian music both originated in the Alps and emphasize accordions.

After touring with Yankovic, Roger formed the Roger Bright Band, which would play for decades at the New Glarus Hotel during the Friday night fish fry and the Saturday polka party. Roger's band also accompanied the star yodelers of New Glarus, like Robbie Schneider and Ernst Jaggi, both immigrants from Switzerland.

In 2001, Roger suffered a fatal heart attack while performing at a polka fest in Colorado. He was performing the music he loved until the last moment of his life. In his

honor the polka festival in New Glarus was renamed the Roger Bright Polka Fest.

The Green County Swiss have demonstrated a surprising degree of cultural cohesiveness, transplanting to America a Swiss microcosm where yodeling and polka music are among the most treasured items of the community's heritage. Moreover, just as is still the case in their homeland of Switzerland, a country with an important tourism industry, the Green County Swiss have realized the potential of showcasing their traditions to attract tourists for the economic benefit of their area.

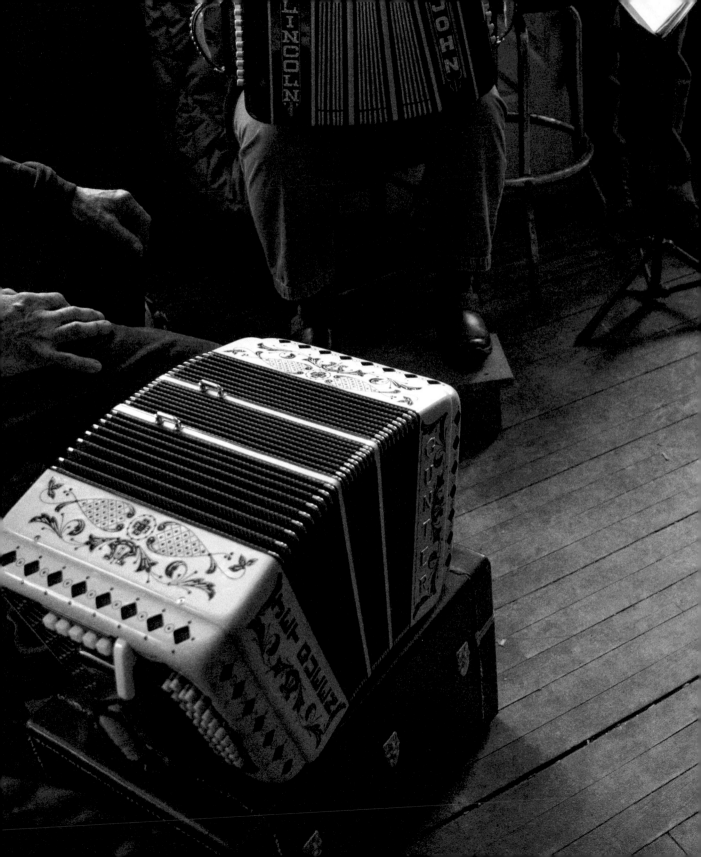

4
AMERICAN POLKA VARIETIES

The central and eastern European immigrants to the Midwest arrived with polkas ringing in their ears. The radical, convention-shattering dance arose from the same historical currents of social unrest on the old continent that launched thousands of European villagers on an uncertain and perilous migration to the American Midwest. Society was changing. People were taking new risks. They dared to polka, they dared to migrate. The old village way of life was fading. People were on the move. And in the upper Midwest all the requisites were lining up for the emergence of new American ethnic polka traditions.

At this very time, Europe was experiencing a revolution in musical instrument technology. Brass bands surged in popularity. Early in the nineteenth century, European inventors devised valves that made brass horns more versatile. The Belgian instrument maker Adolphe Sax created a variety of improved brass instruments. In 1846 he launched his most famous invention, the saxophone, which soon became fantastically popular.[33] Its loud, assertive tone competed well with brass instruments and encouraged musicians to combine brass with woodwinds and reeds in the lineup of marching bands.

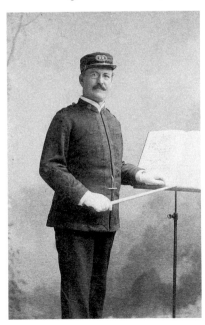

Band leader Patrick Gilmore, ca. 1870
Library of Congress

Concertina players set up their instruments at Martin's Tap in New Berlin, Wisconsin, for a jam session

A ticket to Patrick Gilmore's 1869 National Peace Jubilee in Boston, to benefit Civil War widows and orphans. More than eleven thousand musicians performed in a custom-built coliseum, with room for thirty thousand audience members.

Michael Cummings Collection of P. S. Gilmore Materials, John J. Burns Library, Boston College

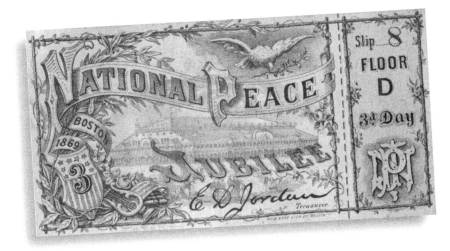

In the United States, the popularity of brass bands flourished, too. Evocative music for the band genre was composed, and New World manufacture of the instruments increased, making them more accessible and affordable. Patrick Gilmore, an immigrant from County Galway, Ireland, arrived in Boston in 1848 and emerged as the most celebrated bandleader and composer of the period. Gilmore initially worked in military bands and, after the Civil War, in celebratory "Peace Jubilees" that featured the nation's finest musicians. In the late nineteenth century Gilmore was succeeded by John Philip Sousa, "the March King," who remains the most celebrated American bandleader and composer.

A good marching band became a requisite of a town's pride. Band concerts in a park gazebo became a highly desirable feature of community life. Many American lips met the mouthpieces of trumpets, saxophones, and tubas to play not only marches but also waltzes and polkas.

Europe experienced parallel developments. The Czech bandleader František Kmoch, a contemporary of Sousa, became the "Bohemian March King." Although he declined ever to move from his hometown of Kolin in Bohemia, he toured with his influential band to Vienna, Budapest, Kraków, and once, all the way to Russia. His well-known compositions, such as "Muziky Muziky," "Koline Koline" (dedicated to his hometown), and "Pod našima okny" ("Under Our Windows"), became phenomenally popular. Urbanek and Sons of Prague sold hundreds of thousands of copies of Kmoch's works. In the United States his sheet music became brisk sellers for Vitak-Elsnic, a still extant Czech American music publisher founded in 1895 in Cincinnati, but based in Chicago for most of its long existence. Kmoch's compositions became an important, still common part of the American polka repertoire.[34]

The latter half of the nineteenth century saw the emergence of another influential musical invention, the free reed squeezeboxes known as accordions and concertinas. Innovative tinkerers in France, England, and Germany developed this new family of instruments using mechanical levers and springs. The sound was produced by reeds based on the principle of the *sheng,* a Chinese free reed instrument. A free reed produces sound as air is forced past a tongue of metal situated in a frame. The Chinese *sheng* was brought via Russia to the rest of Europe where musical instrument inventors began to explore the possibilities of its free reeds.

The squeezebox was a nineteenth-century technological innovation, symbolic of its era much like the programmable keyboard has defined musical performance since the late twentieth century. The squeezebox represented the musical automation of its time. A single accordion or concertina player could replace a small ensemble—because of the instrument's design, a player could produce melodies and harmonies with the right hand while providing rhythmic chords and resonant bass notes with the left.

A prized possession in many a nineteenth-century immigrant's pack was a button accordion or concertina. For others, once in the United States, it became a priority goal to acquire a squeezebox for themselves or for a musically talented child. And those ethnic musicians undoubtedly squeezed the bellows to play a lot of the favorite dance tunes, polkas, waltzes, and schottisches.

The two burgeoning instrumental streams merged. Players of band instruments encountered squeezebox players, and vice versa. They formed impromptu groups. They were joined by fiddlers, too. In the late nineteenth century and the early decades of the twentieth, a polka band had no standard lineup. The earliest recordings, captured by Edison cylinders or on the first discs from the Victor and Columbia recording companies, featured groups with varied instrumental combinations. One group might include a couple of clarinets and violins, an alto horn, and a tuba; while another might have a zither, a violin, and a trombone.

From the 1880s to the 1920s, ethnic polka traditions were in a period of gestation. Specific polka styles with a more standardized instrumental lineup waited for the emergence of influential musicians like "Whoopee" John Wilfahrt, Romy Gosz, Frankie Yankovic, and Li'l Wally Jagiello who, during the first half of the twentieth century, became trendsetters in their respective polka genres.

Defined polka styles appeared along with new inventions and infrastructure. By the 1920s, the music of the most influential bandleaders could be disseminated widely: both directly, through touring as roads were getting better and the automobile had been invented; and indirectly, through such innovations as records that could be played on the Victrolas in many a family's parlor and radio broadcasts that carried

their performances far and wide. Local stations in many communities featured home-grown musicians in live broadcasts. Stations like WCCO in Minneapolis, which could be heard in several states as well as in parts of Canada, were responsible for creating regional stars like Whoopee John or the Six Fat Dutchmen.

Over time, ethnic groups developed their own recognizable polka style, each with its own typical sound and combination of instruments. The most prevalent polka styles discussed in the following chapters—Czech, German, Polish, Slovenian, and Mexican—all combine brass band and squeezebox instrumentation. These styles have become an important core of upper midwestern polka. Other related musical traditions, which often use different instruments, overlap with these polka styles. The epicenter of the squeezebox and brass band earthquake was in central Europe. On its northern and southern fringes, other instrumental traditions were persisting or developing in other directions.

One example was the fiddle. In western Scandinavia in the mid-nineteenth century, the newfangled accordion had yet to arrive. Instead, Scandinavian immigrants brought their fiddles to America. The fiddle remained the main folk instrument in midwestern Norwegian and Swedish American communities, where nowadays the fiddler, or *spelman,* vies for the limelight with the accordionist.

Scandinavian fiddlers arriving in the Midwest soon swapped music with Anglo-Celtic fiddlers in the region and with the French fiddlers from Canada who were doing seasonal work in the northern lumber camps. As a result, the Norwegian and Swedish musicians of the Midwest developed a repertoire that blends Scandinavian *valsen,* schottisches, and polkas with plenty of old American sentimental tunes, two-steps, and hoedowns.

The fiddle-dominated music had less presence in the commercial dancehall business, but it remained important in rural neighborhood house parties, Sons of Norway lodge halls, and smaller tavern venues. But Scandinavian musicians who sought to "cross over" into the ballroom scene had to rely on louder instruments. Norwegian immigrant Thorstein Skarning, a virtuoso player of the chromatic button accordion, toured the upper Midwest for two decades beginning in 1917. To produce adequate volume for a ballroom in the days before reliable sound amplification, Skarning would use up to five reed and brass players plus a tuba, piano, and drums. To get sufficient volume, Leighton "Skipper" Berg from Albert Lea, Minnesota, used several accordions in his Viking Accordion Band. The group toured the Midwest region from 1930 until the mid-1950s.

The violin retained a toehold in the commercial music scene of the upper Midwest. While popular Scandinavian bands like Skarning's and Berg's eschewed the

Leighton "Skipper"
Berg's Viking
Accordion Band
from Albert Lea,
Minnesota
Courtesy of
Dennis Brown

fiddle, Ted Johnson, a Swedish American violinist and bandleader from Minneapolis active in the 1930s and '40s, emphasized a softer violin and accordion sound; but he tended to play in more intimate venues, in restaurants rather than ballrooms.

The Norwegian and Swedish fiddle traditions enjoyed a resurgence in later decades. Madison's Goose Island Ramblers, a Norwegian polkabilly band, had regular appearances on Chicago radio station WLS's *National Barn Dance* show in the early 1940s, prominently featuring the hoedown and Scandinavian-style fiddling of K. Wendell "Wendy" Whitford. After a long hiatus, the band re-formed in the 1960s when Whitford teamed up with George Gilbertsen, a fine musician who had been crowned Wisconsin's champion fiddler at the 1948 State Centennial Fair, and accordionist Bruce Bollerud, a versatile instrumentalist and vocalist in English and Norwegian.

Thanks to fieldwork in the 1960s and '70s by Bob Andresen, a guitarist and Scandinavian old-time music enthusiast from Duluth, Minnesota, many old-time Scandinavian American musicians have been rediscovered and recorded, notably the fiddler Leonard Finseth from Mondovi, Wisconsin, whose music has influenced a new generation of Norwegian American fiddlers such as Beth Hoven Rotto from Decorah, Iowa, and Tilford "Tip" Bagstad from Coon Valley, Wisconsin.

In the Twin Cities, old-time Swedish American fiddle traditions were reinvigorated by Swedish immigrant Edwin Johnson, who formed the American Spelmans

Trio with his son Bruce and his grandson Paul Dahlin. Edwin died in the 1980s, but his descendants help keep his music alive through the American-Swedish Institute's fiddle ensemble, Spelmanslag.

The tamburitza is another instrument on which polkas are played. Croatians and Serbs from the Austro-Hungarian Empire experienced a unique instrumental revolution in the late nineteenth century. As part of a south Slavic movement for cultural affirmation, a simple village lute called the tamburitza was refined and standardized by trained musicians for orchestral use. The orchestral tamburitzas are fretted, like guitars and mandolins; are played with a pick; and range in size from smaller than a mandolin to as large as a string bass. Orchestral tamburitza music was taught in schools and cultural societies; the orchestras offered concerts of classical and patriotic music. The common people whisked these improved instruments out the back door of the concert hall and used them to play folks songs and dance music in small ensembles in the taverns of villages and towns.

Mass emigration from these parts of Europe to the United States began at the end of the nineteenth century. By the beginning of the twentieth century, tamburitza combos that played polkas, waltzes, and *kolo* line dances were forming in midwestern mining and industrial towns where these immigrants settled.

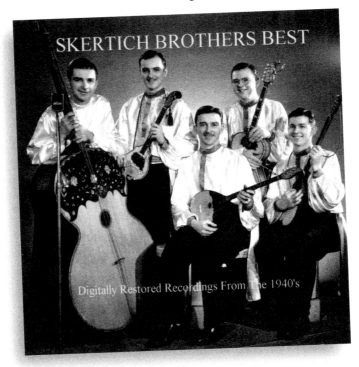

A record from the Skertich Brothers, a tamburitza group from Chicago that was popular in the 1940s

Courtesy of Balkan Records

Unlike the better-known polka instruments, the tamburitza has remained largely unfamiliar outside of Serbian and Croatian ethnic communities. However, during the height of the post–World War II polka craze, a tamburitza group called the Skertich Brothers made a concerted attempt to "cross over." At a time when the major recording companies were swiftly dropping ethnic performers from their labels, Columbia Records continued to release discs by the Skertich Brothers, hoping the bright, tinkling sound of the tamburitza ensemble would have wide appeal. One side of their record typically featured an instrumental polka or waltz aimed at a general audience. The other side featured a vocal number sung in Croatian to appeal to the ethnic market. Another tamburitza group, led by Marty Kapugi, was the house band on Chicago's long-running *International Café* television program. And a group called the Crljenica Brothers provided tamburitza music for a dozen or more Hollywood movies, including the famous "Lara's Theme" from *Doctor Zhivago*. There is a small, dedicated network of Balkan folk dance enthusiasts who follow tamburitza music, but tamburitza groups never achieved wide fame.

Like the south Slavs who emigrated in their greatest numbers from the 1890s to World War I, the Finns, arriving around the same time, were relative latecomers to the upper midwestern ethnic mix. Their music is distinct from the major polka styles, but not because they play a different instrument. Finnish villagers had warmly embraced the accordion in their homeland by the time they migrated to the Lake Superior region. They came to mine copper and iron, cut timber, and farm the cutover land. An immigrant musician named Hiski Salomaa, living in the Upper Peninsula of Michigan, performed to the accompaniment of a polka band and has been dubbed "the Finnish Woody Guthrie," thanks to his militant pro-worker views.

Finnish American accordionists such as the legendary Viola Turpeinen, a pioneer female polka star, played a unique repertoire of polkas, waltzes, and schottisches that blended indigenous Finnish music with musical influences from Finland's neighbors and sometime-rulers, Russia and Sweden. Though the music is uniquely Finnish, the Finns' frequent minor-key dance tunes sound like Russian music, while their perky, major-key numbers are similar to Swedish tunes. Finnish American bands such as Third Generation from Duluth, Wisconsin, the Oulu Hotshots from Iron River, Wisconsin, and the duo Al Reko and Oren Tikkanen (Al is from Minnesota and Oren from Michigan) made a continuing contribution to this unique polka style.

The nineteenth-century polka craze also entered Mexico from Europe. The French invaded Mexico in the 1860s, bringing with them musical influences that included the polka. Immigrant Czech and German bandleaders instructed brass bands in Mexico, and Mexican musicians developed indigenous *banda* styles associated with a number

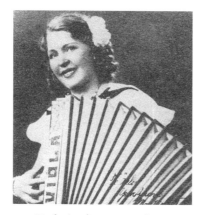

Finnish-American Viola Turpeinen, originally from Champion, Michigan, was considered one of the world's best female accordion players in the 1930s.
Courtesy of the Center for the Study of Upper Midwestern Cultures

of Mexican regions, notably Sinaloa and Durango. One currently popular *banda* style actually originated in the Midwest. In Chicago, immigrants from Durango created the music known as *banda duranguense*. For the sake of modernity and convenience, *duranguense* musicians began to substitute electronic keyboards for some of the brass instruments. Grupo Montez de Durango, Alacranes Musical, Mazizo All-Starz, and Los Horoscopos de Durango are among the prominent initiators and proponents of this music.

Early in the twentieth century, the accordion, especially the small two- and three-row button accordion, became very popular in northern Mexico and in neighboring Texas. Mexican musicians in Texas interacted with Czech, German, and Polish immigrants there to shape the polka style of the Texas-Mexican *conjuntos*. In the 1930s Narciso Martinez was a key pioneer recording artist of the *conjunto* style. He established a perky, staccato manner of play, using only the right-hand side of the button accordion. For rhythm, *conjunto* bands relied on a unique Mexican guitar, the *bajo sexto*. Around the same time, vocalist and guitarist Lydia Mendoza established herself as the premier singer in the Texas-Mexican musical style.

Mexican Americans have migrated to many regions of the United States, including the Midwest, bringing the *conjunto* style of polka music and dancing with them. Unlike the Euro-American polka music, which had fallen out of mainstream favor by the 1950s, Mexican polkas and waltzes have remained a staple of popular music in the extensive world of Spanish-language recordings, radio, and television in the United States.

Today, most polka music styles are known by the name of the nationality that

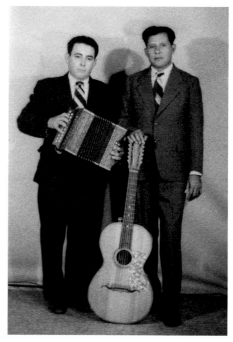

Narciso Martinez (left) with band member Santiago Almeida
Courtesy of the Arhoolie Foundation

had the greatest role in their origin. However, when these styles were still coalescing in the mid-twentieth century, European ethnic communities were far from isolated from one other. As a result, these polka scenes have always included many musicians who are not of the same nationality as the style's name. For example, in Milwaukee, with its large Polish American population Frankie Yankovic's Slovenian became the most popular idiom. Along with Slovenian American musicians like Louie Bashell, Hank Magayne, and Frank Bevsek, Polish American musicians like concertinist Don Gralak and accordionist Barbara Flanum Lane (Kaszubowski is her maiden name) were important performers of the Slovenian style. Other important non-Slovenian purveyors of Slovenian polka in southeastern Wisconsin include Verne and Steve Meisner and Gordon Hartmann (Austrian); Tony Rademacher and Joey Klaas (German); Joey Tantillo and Louis Salerno (Italian); and Greg Anderson and Jay Brodersen (Scandinavian).

Other examples abound. In the Stevens Point, Wisconsin, area, the German American "Dutchman" style has been played avidly by Polish American musicians. Romy Gosz, the most famous originator of the Czech/Bohemian polka style, was of German heritage. Belgians in eastern Wisconsin have played in the Czech/Bohemian style, too.

The mixed-ethnic participation shows that polka is both ethnic and regional. While each polka style may have an ethnic name, polka is enjoyed by musicians and dancers who think of it as part of their midwestern regional tradition.

As immigrants turned into midwesterners, polka evolved into a versatile and flexible symbol, at times representing ethnic identity and at other times denoting regional identity—the home-grown music of the Midwest.

Concertina or Accordion?

A sure way to irritate a concertina player is to call her instrument an accordion. And you're bound to irritate a button accordion player by calling his instrument a concertina just because it has buttons instead of a piano-style keyboard.

There is a good-natured rivalry between concertina and accordion players, much like the rivalry of canoeists and kayakers. It's hard, however, to blame a casual listener for mixing them up. Both instruments have bellows and create their sound through metal free reeds, but the resemblance stops there.

So, what is the difference between the various types of squeezeboxes? The answer can be confusing—so if you don't like complications and convolutions, you'd better stop reading this section right here.

One easy rule to remember is that if the buttons or keys are on the front of the instrument, it's an accordion; if they're on the sides, it's a concertina. That is, except for the Schwyzerörgeli, the little Swiss button accordion with right-hand buttons on the front and left-hand buttons on the side.

Although it's a good outward indicator, the location of the buttons actually isn't the crucial distinction. When nineteenth-century European tinkerers were inventing these wacky instruments, they tried differing arrangements of buttons and keys to allow a player to make music. Most of the early squeezebox instruments were "push-pull," meaning a different note was produced depending on whether a player was

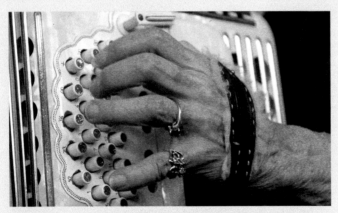

Millie Kaminski playing the concertina at Martin's Tap in New Berlin, Wisconsin

POLKA INTERLUDE

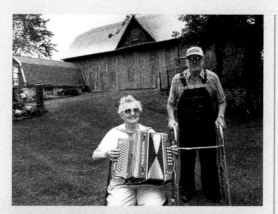

Florence Wiedmeyer, a Dodge County resident and lifelong button accordion player, pictured here with her husband Harold. As a young girl Florence played at some of the local bars. Photo ca. 2004
WHi Image ID 80507

extending or compressing the bellows—in or out.

At first, each button could produce only one note per direction. Then, in 1829, an Austrian man named Cyrill Demian got the bright idea that a single, left-hand button could be outfitted to play a two- or three-note chord. *Akkord* is the German word for chord, so the instrument Demian developed became known as the *Akkordeon.*

Concertinas, meanwhile, still only produce one note per button. If a player wants to produce a chord with her left hand, she has to press two or more buttons simultaneously.

Another primary difference is the arrangement of the right-hand buttons or keys, which produce the melody and harmonies. Accordion makers have tried to preserve some sort of musical logic to the arrangement of the buttons and keys. On button accordions, the main notes of a chord are lined up in each row of buttons. On keyboard accordions, the notes are arranged in the manner of a piano keyboard.

On concertinas, however, the buttons are organized in arcs, with no musical logic to their arrangement. Much like the idea for the letters on a typewriter keyboard, concertina buttons are arranged according to how often they are used and for general convenience of play.

For nearly two centuries, musical tinkerers have devised quite an array of squeezeboxes that have become common in the traditional music of people around the world. But don't expect a player of one type of accordion or concertina necessarily to be able to play another variety of squeezebox. It is a unique skill to master the keyboard arrangement and bellows action of each type.

THE WISCONSIN "BOHEMIAN" POLKA

On a bright June morning in 2013, with Dick Blau's bag of photo equipment on my car's backseat, the two of us headed up Highway 14, the familiar route from Madison to Hillsboro, Wisconsin. I didn't need to consult a map; I knew the way. During my Arts Board career, I had many occasions to assist with cultural efforts in that western Wisconsin town of 1,400 people, a small commercial hub that serves the needs of surrounding dairy farms.

This particular day, one of Hillsboro's most important cultural events was taking place, Český Den, or Czech Day, an early-summer festival featuring polka dancing, which had been staged for nearly thirty years by a town that bills itself as "the Czech Capital of Wisconsin."

After a pleasant drive through green, rolling hills, we arrived at Fireman's Park on the edge of Hillsboro, purchased admission buttons adorned with a folksy Czech motif, and entered the grounds.

Most of the festival events took place in an elongated metal pole barn. It was a no-nonsense, functional space, furnished with long folding tables and chairs. At one end, you could buy roast pork dinners, and at the other, kolache pastries for dessert.

In the middle of the barn, a wooden dance floor had been set down in front of a wide bandstand with room for two bands side by side. As is common at polka festivals, the equipment of both bands is put in place so they can alternate playing every hour without a pause to set up.

Both of the bands for that day's festival—the Orval Konop Dance Band from Green Bay and the Mark Jirikovec Band from Denmark, Wisconsin—had driven to Hillsboro from other large Czech settlements farther east. The Czechs in their section of northeastern Wisconsin are concentrated between the cities of Manitowoc and

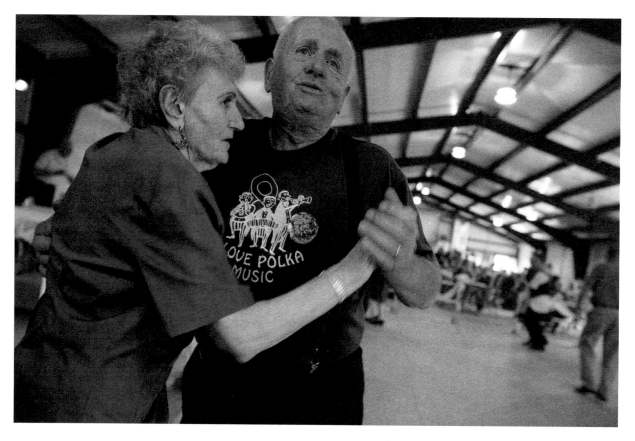

Polka dancers
at Český Den
in Hillsboro,
June 2013

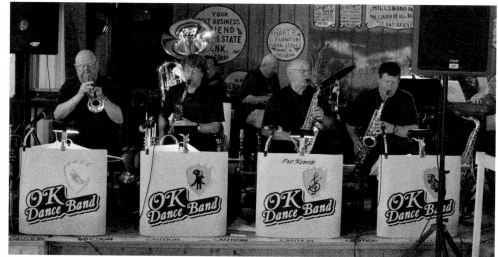

Orval Konop's OK
Dance Band, from
Green Bay, playing
at the Český Den
in June 2013

This 2003 CD cover features a photograph of a wedding procession in Kewaunee County, Wisconsin, led by the Blahnik Harp Orchestra, a Bohemian polka-playing band, in the 1890s. The CD, *Golden Horns on Green Fields,* was released by the Kewaunee County Agriculture History Association.

Original image from of the Kewaunee County Historical Society; CD cover from the personal collection of Rick March

Green Bay. The region has produced an astounding array of Czech music ensembles, known locally as Bohemian bands. In fact, they seldom use the term *polka band,* as polka is only one of the rhythms they play.

The term *Bohemian* reflects the fact that early Czech immigrants typically identified themselves not by their Czech nationality but as people from the Austro-Hungarian province of Bohemia. The term seemed more inclusive perhaps. At the time of their departure, Bohemia had a sizable minority of Germans. And in their new homeland in Wisconsin, the Czechs likewise found they had plenty of ethnic German neighbors, as well as Poles and Belgians. The neighboring nationalities readily accepted the influence of the musically motivated Czechs, and everyone in the area played in or danced to Bohemian bands.

The region's strong music tradition was initiated by immigrants who founded town brass bands in the nineteenth century. They raised funds to purchase instruments and often flashy, military-style band uniforms.

Musical arrangements of Bohemian bands have remained the most complex in the polka tradition, exemplified by multipart compositions from Czech composers like František Kmoch. Czech bands tend to perform all sections of a composition, while the German American Dutchman-style bands, by contrast, frequently omit some segments of these tunes to simplify the piece.

Most polkas contain an eight-measure "A part" followed by a "B part," a related melodic passage that seems to "answer" the musical statement that it follows. Czech polka listeners often hear an additional interlude between the parts. In Czech compositions the B part often includes vocal lyrics. Some tunes have even more parts, notably

the famous tune "Babičina radost," or "Grandmother's Joy Laendler," with a total of six stunning parts.

Beginning in the 1920s, a major expansion of social dancing had swept the country. Spacious dance halls with fine hardwood floors became all the rage. These halls drew talent from the ranks of marching-band musicians, and seven- or eight-piece groups proliferated to meet a growing demand for dance music. In northeastern Wisconsin, the old traditional dances, polkas, waltzes, ländlers, and schottisches were soon joined by newly popular fox trots—still today called "moderns" by polka people even though the tunes were composed long ago—in the 1920s and '30s. Old-timers often have told me that from the 1920s through the 1950s, there was a dance going on in a tavern or a dance hall somewhere in northeastern Wisconsin every single night of the week. And no band playing at those dances was more popular than the ensemble of Romy Gosz.

Trumpeter Roman "Romy" Gosz was the key musician to establish the Wisconsin Bohemian style. Romy was born on a farm in Wisconsin's Manitowoc County. His whole family seems to have been musical. In 1921 Romy's father, Paul Gosz, organized his four sons into a family band to play the old Czech polkas and waltzes. Their lineup

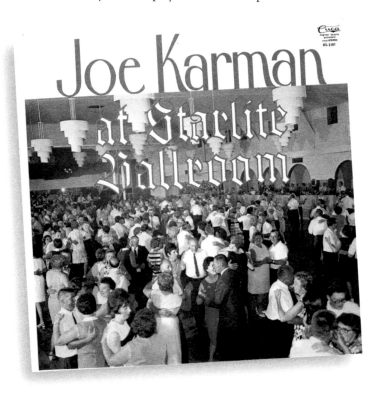

Album cover for Joe Karman's Bohemian polka band, featuring a packed crowd at the Starlite Ballroom in Stevens Point, Wisconsin, in the late-1950s
Courtesy of Cuca Records

included two trumpets and two clarinet players, who doubled on saxophone, tuba, piano, and drums.

Romy Gosz's formal musical training was scanty. He took just one piano lesson at age seven. Soon after, he notified his teacher that he couldn't come for the next lesson because he had to play for a dance. At age eleven, he became a regular member of his father's band on piano, and at eighteen, when his father, Paul, wished to bow out, Romy became its bandleader.

Rural entertainers had to be versatile in that era. Frequently, the Paul Gosz Band started out the evening as a basketball team, playing against a local lineup. After the game, they changed clothes, got out their instruments, and played for dancing crowds on the smooth floor of the basketball court.[35]

In 1931 Romy switched to trumpet to replace an absent band member. The results were so striking he never went back to piano. Romy's distinctive, potent, emotional trumpet playing became renowned as the band's trademark. In 1933 Romy began his recording career, traveling with his band to recording studios in Chicago. His

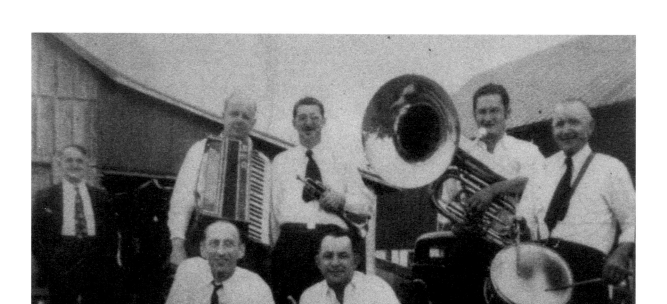

The Romy Gosz
Band performing
at a wedding in the
mid-to-late 1930s

From the Collection
of James P. Leary
through the courtesy
of Jim Eisenmann

discs sold well. He began to tour nationally and, like Frankie Yankovic, was often touted in the press as an American "Polka King." Consumed by a passion for music, touring, and good times, Romy lived hard, died young at age fifty-six, and left a beautiful memory.

Romy's music became known as "Gosz style," and dozens of bands proliferated to mimic his approach. Bandleaders like Don Schlies, Gordy Reckelberg, the Greiner Brothers, and Rudy Plocar remained faithful to the original Gosz sound. Other bands, like those of Jerry Voelker, Dick Rodgers, and Jerry Schneider, combined Gosz's sound with other influences to produce their own distinctive Bohemian styles.

At Český Den in Hillsboro, we could hear echoes of Romy Gosz in the Orval Konop and Mark Jirikovec bands as their music reverberated that summer afternoon in the Fireman's Park pole barn. Several couples, mostly elderly, glided around the dance floor. A number of dancers sported T-shirts emblazoned with Czech emblems or polka-boosting slogans. One woman's shirt proclaimed she was "Czech by

Marriage." A middle-aged polka enthusiast from Green Bay wore a folk costume plus a tiara and sash, indicating she was this year's Queen of Český Den.

Compared to the crowds I saw in Hillboro a decade earlier, the dance seemed sparsely attended. Late in the afternoon there was a pause in the music for an antique tractor parade. Farming is integral to Czech heritage in Hillsboro. On a field nearby, three or four dozen restored tractors were on display—red, green, and yellow 1920s-to-1970s models manufactured by International Harvester, John Deere, and Minneapolis-Moline. As festival attendees watched, drivers ran the vintage machines past the pole barn, kicking up a little dust, then turned around and came back again. As soon as the racket from the tractors' engines was stilled, the Bohemian music resumed, and people went back inside for more dancing. Soon it was sunset and time to go home.

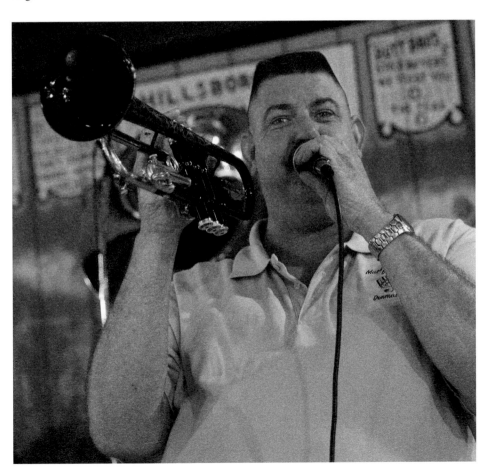

Bandleader Mark Jirikovec from Denmark, Wisconsin, playing at the Český Den in June 2013

Beer and Polka

Polkas and beer just seem to go together. Beer is a favorite beverage in central European, polka-loving nations. In the Czech Republic, the western Bohemian city of Pilsen gave its name to pilsner, one of the world's favorite lager beers. Since the thirteenth century, beer has been brewed in the small southern Bohemian city of České Budějovice, known as Budweis in German. You might have heard of a beer with a moniker derived from that city's name and brewed by a certain American

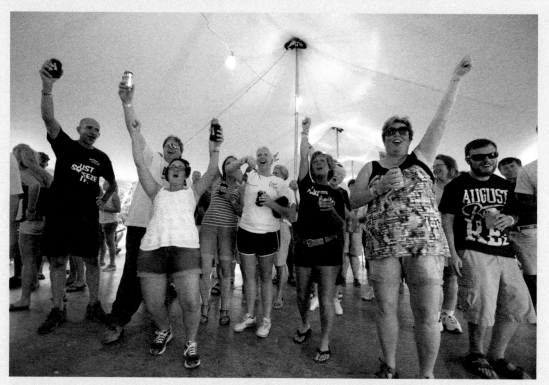

A crowd at the 2013 Polka Days in Pulaski, Wisconsin, cheers on a band, with—you guessed it—beer in hand.

POLKA INTERLUDE

company. Germans, too, take their beer seriously. Since 1487, the wholesomeness of German beers has been guaranteed by the *Reinheitsgebot* beer purity regulations. Perhaps the most legendary beer hall in the world is Munich's Hofbrauhaus, the site of the famed Munich Oktoberfest. Across these cultures, beer-drinking and polka-dancing traditions mark many festive occasions.

Thus it comes as no surprise that arguably the most famous polka in the United States is "Beer Barrel Polka," otherwise known as "Roll Out the Barrel" and called "Rosamunde" in German or "Škoda lásky" ("Wasted Love") in its original Czech. Few people know, however, that this is not a long-ago folk song but rather a twentieth-century composition by Jaromir Vejvoda, a humble violin and flügelhorn player from Prague. Vejvoda wrote the tune in 1927 while working as a bartender in his father-in-law's tavern.

The song was first performed solely as an instrumental piece. In 1934 Czech lyrics were written, and soon thereafter the German accordionist Will Glahé recorded the song as "Rosamunde." A few years later, Glahé re-recorded an English-language version, and by 1939 "Beer Barrel

Polka" became a big hit in the United States. During World War II the song was recorded by such luminaries as Glenn Miller, Benny Goodman, and most famously, the Andrews Sisters. Polka musicians confess that sometimes they tire of the inevitable requests to play "Beer Barrel" at every performance, but they acknowledge that at least it is a really good polka.

The list of well-known polka songs celebrating beer goes on and on. Across the Midwest, "In Heaven There Is No Beer" is almost as popular as "Beer Barrel." The song is a translation of the German song *"Im Himmel gibt's kein Bier,"* which was originally composed for a 1956 German movie musical, *Die Fischerin vom Bodensee* ("The Fisher Girl of Lake Constance").

Frankie Yankovic had a hit with "Milwaukee Polka," in which he crooned, "Beer from Milwaukee, the very best in town." In another polka, "No Beer Today," Frankie bemoaned a local blue law that forbade beer sales on Sunday, and he asserted in a song in waltz tempo, "I stopped for a beer," and "never got home for a year."

The lure of beer to delay a man's arrival at home reappears in a couple of waltzes

POLKA INTERLUDE

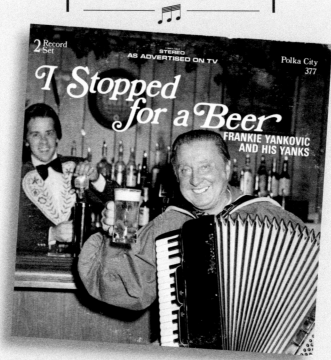

A popular record from Frankie Yankovic
Personal collection of Rick March

by the Dick Rodgers Orchestra out of Pulaski, Wisconsin, "Home, Home, Why Go Home?" and "It Took Me All Night to Get Home Last Night." Jerry Voelker, from Door County, Wisconsin, enumerated the troubles caused by too much beer in a song called "Barley Pop." The singer "gets his nose stuck in a glass of barley pop," chases a "jukebox Juliet," and winds up bruised and beaten by "the guy behind the bar." Lawrence Duchow made a polka-style cover of the country music parody "Seven Beers with the Wrong Woman" in which the protagonist gets his wallet stolen by a woman he meets in a bar, whose husband shows up to throw him out.

The ill effects of beer, as in "Barley Pop," are rarely mentioned, however. Duchow also recorded "More Beer," a song set to the tune of the old German standard, "The Jolly Coppersmith," in which "Gus and Otto get together for a glass of beer."

POLKA INTERLUDE

They are "friendly folks" who "chat a while and tell each other jokes." Beer can even make a weak polka band sound good. In the song "Milwaukee Waltz" popularized by Minnesota's Deutschmeisters, "the trumpets are off key, the tuba is loud" but "the beer flows like wine, after fifteen small bottles, the band she sounds fine."

The European tradition of pairing beer and polka has enjoyed a longtime home in the American Midwest. Dutchman and Bohemian bands often play "Praha Polka," a favorite song in Czech that declares *"Když jsme opustili pivovaru, slunce svitilo"* ("When we left the brewery, the sun was shining"). And the scores of annual Oktoberfest celebrations that happen across the Midwest wouldn't be complete without singing the German toast songs "Ein Prosit" and "Im Munchen steht ein Hofbrauhaus."

Ein, zwei, g'suffa! (One, two, drink up!)

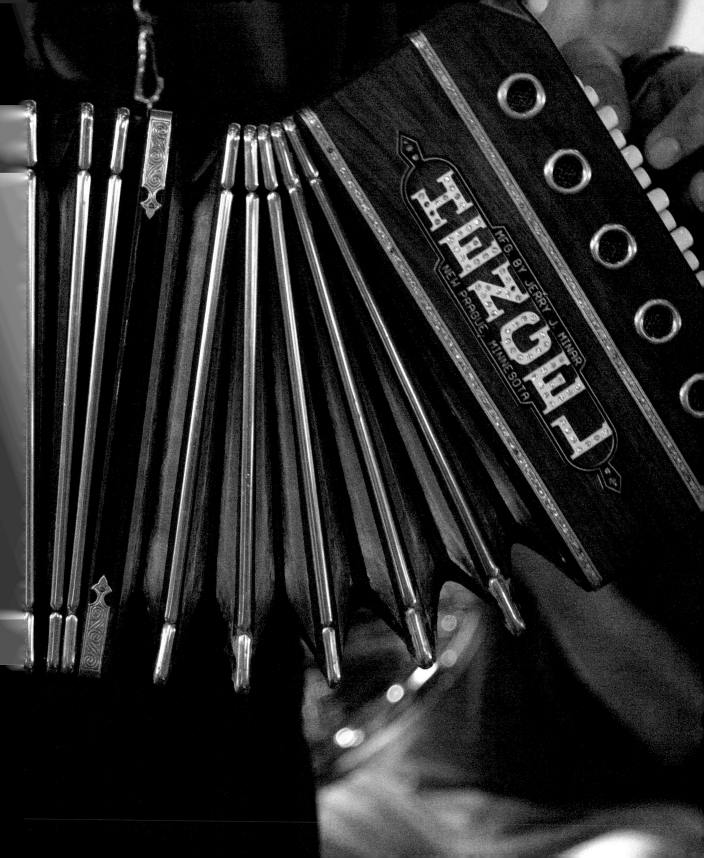

6

DUTCHMAN-STYLE POLKA

The fields around Monroe, Wisconsin, were intensely green that June afternoon, so much so that the corn and alfalfa fields looked rendered in Technicolor. This is dairy-farming country. Although immigrants from several European countries settled in this part of southern Wisconsin in the nineteenth century, the cheese-making Swiss put the most visible stamp on this aptly named Green County.

Just as it does in nearby New Glarus, a Swiss atmosphere pervades Monroe through the active yodel choirs, alphorn players, and celebrated Swiss foodways. In 1914, Monroe established Cheese Days, celebrating the region's dairy history and other Swiss traditions. Now, on most any afternoon, local elders enjoy games of *Krüzjass,* a favorite Swiss card game, at Baumgartner's Cheese Store and Tavern on the courthouse square, known as the Stube.

Dick and I were heading for another local institution, Monroe Turner Hall, a couple of blocks south of the square. The *Turnverein* was a gymnastics and cultural society established in Monroe in 1868. The current hall, built in 1938 to replace the burned-down original building, was designed in the architectural style of a chalet from the Emmenthal region of Switzerland. The interior is decorated with *Bauernmalerei* folk art.

For the past century and a half, Turner Hall has been the main community gathering place. And this day was no exception. A crowd of mostly elderly but enthusiastic and skilled dancers had turned out to polka and waltz to the strains of a band from Iowa, Becky & the Ivanhoe Dutchmen. Despite the Swiss setting, the band played a style of polka created by Bohemian German immigrants in Minnesota—a style that's been widely embraced by midwesterners.

Barefoot Becky Livermore (she likes to perform sans shoes) offers a modern version of Old World German heritage in many of her songs; but she also plays plenty of

Karl Hartwich playing his Hengel concertina

Two young women in Swiss costume holding an Alpine horn, at the cheese celebration in Monroe, Wisconsin, now known as Cheese Days, ca. 1955

WHi Image ID 43995

the Bohemian Czech songs that are prevalent in Dutchman repertoire and popular in her home region of eastern Iowa, an important Czech American enclave.

In 1980, at age ten, Becky began taking accordion lessons from an elderly neighbor woman. Another neighbor, Ed Ulch, was the leader of a band called The Jolly Bohemians. Two years later, Becky began playing with them. In 1988 when Becky was still a high school senior, she purchased the Jolly Bohemians' music library and founded her own band, the Ivanhoe Dutchmen—named after the road on which her family's farm is located.

Thanks to Becky's talent and enterprise, the Ivanhoe Dutchmen have become one of the most prominent Dutchman groups in the Midwest, playing as many as twenty dates per month. Becky's band is noted for her fine accordion skills and her splendid vocals, singing in English, Czech, and German.

Becky is one of the younger musicians following a venerable tradition.

Through the middle decades of the twentieth century, the Dutchman sound—with its bouncy rhythm on tuba, its blended brass, and reeds trading solos with a concertina or accordion—achieved huge popularity, particularly among rural and small-town

midwesterners. The older crowd at Turner Hall no doubt enjoyed dancing during that heyday half a century ago. Many couples executed skilled moves. In addition to polka, they danced perky schottisches and circle two-steps, in which couples change partners several times during each song.

Since the early 1980s when I began attending Dutchman dances, attendance has fallen off and the core audience has aged. I'm pleased that I had the good fortune to participate while Dutchman was still going strong, and to become a firm friend of one of the most gifted musicians ever to play in this idiom, Karl Hartwich.

In 2002 I made my biggest winnings ever in a poker game, about twelve dollars in nickels and dimes, on Karl's band bus, which was actually a former airport van, on our way back to Wisconsin from Omaha. I had cooked up an opportunity for Karl and the Country Dutchmen to appear in a documentary about polka produced by Nebraska Educational Television. They filmed four bands in the spacious ballroom of Sokol Hall in Omaha's Little Bohemia neighborhood. During the last number of Karl's set, his delighted fans took a break from dancing to face the stage and express their reverence for his band, bowing with arms extended as if paying homage to a medieval king.

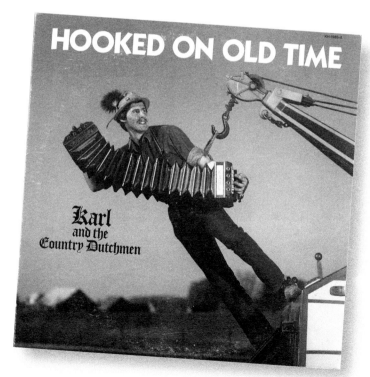

The title of Karl Hartwich's 1986 album parodied the use of "hooked on," a ubiquitous marketing phrase in the 1980s that began in 1981 with the "Hooked on Classics" record series and spread to many other musical and nonmusical products such as "Hooked on Jazz," "Hooked on Phonics," and "Hooked on Golf."
Courtesy of
UW Mills Music Library

"You guys are nuts," Karl chortled. Yes, he knows there are people who say he is the world's best Dutchman-style player of the Chemnitzer concertina, but he'd never say it, or scarcely think it, himself. He's unpretentious and friendly, a regular guy. Before he had it refinished, his vintage Hengel concertina's celluloid encasing was cracking and splitting. Often, he'd rip off a dime-sized chunk of celluloid and hand it to a surprised fan who had come up to the stage to request a song. Likewise, his sparkling music—and Dutchman music, in general—puts on no airs.

Karl and I became fast friends, taking opportunities to go fishing and camping together on the Mississippi River near his home in Trempealeau, Wisconsin. There is some kind of music running through his head every second. Out on his little fishing boat, Karl keeps his cassette player fired up, with tapes of classic Dutchman musicians, or Slovenian polka, or Dixieland jazz, or country music. Like a good jazz musician, he can't listen to a melody without exploring the improvisational possibilities surrounding the tune. He'll start scatting the riffs while holding a fishing rod, or in another setting, with a concertina in his hands, his musical idea goes instantaneously from his head to his fingers to the concertina's voice.

Karl came to the Dutchman tradition naturally. It has been a key, pervasive vernacular music in the upper Midwest, his home region, particularly among people like him, rural and small-town residents of German American heritage. With his family's

Syl Liebl and the Jolly Swiss Boys in 1968. Syl Liebl, first row on the left, is joined by his son Syl Liebl, Jr, seated third from left, and his daughter Carol Liebl Seebauer, standing in the rear. Syl Liebl's concertina skills inspired younger generations of musicians across the Mississippi River area.

Courtesy of Dennis Brown

Whoopee John
Wilfahrt playing
his Pearl Queen
concertina while
wearing Lederhosen
and a Jäger's hat
Courtesy of
Dennis Brown

roots in the upper Mississippi River valley, he grew up on a farm a little farther downriver in Orion, Illinois. In the 1970s when the family went north to visit relatives, Karl often heard the music of Syl Liebl, the primo concertina player in the La Crosse, Wisconsin, area. Syl had moved to Wisconsin from Wanda, Minnesota, a small farming town near the great, music-originating town of New Ulm.

The community of Germans from Bohemia in that part of southern Minnesota is every bit as music-obsessed as the Bohemian Czechs of northeastern Wisconsin. Early in the twentieth century in Sigel Township near New Ulm, the mother of a young farm boy named John Anthony Wilfahrt invested in an accordion for her talented son. It paid off handsomely. He went on to become Whoopee John, the most famous of the Dutchman musicians. From the 1920s through the 1950s, Whoopee John was the bandleader of the flagship Dutchman orchestra. His band's eminence was closely rivaled by a host of others from the same region, such as the Six Fat Dutchmen, Fezz Fritsche, and Babe Wagner, making New Ulm the Music City of the North.

The early Dutchman bands centered their sound on a strong complement of brass and reed instruments backed by a rhythm section of piano or banjo, tuba, and drums. The Dutchman sound is completely different from Slovenian

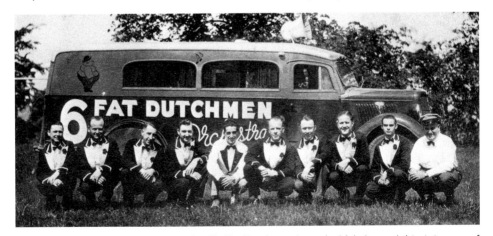

From the 1930s through the 1960s, the Six Fat Dutchmen toured widely in an eight-state area of the upper Midwest. Their band buses, like this one in the mid-1930s, prominently advertised the group. Courtesy of Dennis Brown

Christy Hengel, concertina maker, musician, and bandleader from New Ulm, Minnesota, ca. 1960

Courtesy of Dennis Brown

polka, which emphasizes a pair of accordions and doesn't use a tuba. Dutchman style is similar to Bohemian in instrumentation; however, the rhythm is more syncopated and the tonal timbre is smoother.

The Chemnitzer concertina was a part of the Dutchman mix, too; its role became even more prominent as microphones and amplification improved, which allowed the squeezebox to compete in volume with a gaggle of horn players. Concertina players like Elmer Scheid, Johnny Gag, Ernie Coopman, and the renowned concertina maker and player Christy Hengel became some of the big stars of the Dutchman idiom. Small Dutchman combos began to get rid of their wind instruments, instead keeping just a concertina or two, plus a rhythm section. This kind of group is typically called "concertina oompah."

The Dutchman genre referenced the cultural traditions of the largest ethnicity in the region, German Americans. But from the 1930s to the 1960s it also attained a high level of commercial success among midwesterners of all backgrounds, thanks to the strength of the musicians and the widespread popularity of ballroom dancing in that era. The brass, reed, and rhythm instrumentation sounded a lot like the popular dance bands of that era; and, seated with their instruments behind bandstands emblazoned with the band's name, Dutchman groups resembled the mainstream popular big bands, too.

Radio broadcasts of Whoopee John and other Dutchman bands were heard all over Minnesota and surrounding states, as well as in parts of Canada. The bands toured the whole region, often playing at mainstream, big-city ballrooms. Dutchman recordings were big sellers, as well. In 1934, when the Kapp brothers established Decca Records, Bing Crosby was the first act they signed, and Whoopee John the second. Whoopee went on to make more than two hundred records for Decca, and he made more than a thousand recordings during his entire career. The Dutchman bands made southern Minnesota the epicenter of a strong segment of the music industry and an American music tradition.[36]

Like Bohemian bands, the Dutchman artists long eschewed the term *polka band*, preferring the term *old-time music* instead. To emphasize that his band was popular and up-to-date despite this description, promotional posters for Whoopee John's band

described them as "radio-TV recording artists" who played "modern old-time" music. Francis McMahan, who led a Madison-based Dutchman group called the Shamrock Band in the 1950s and '60s, told me they liked the term *old-time* because tunes in polka rhythm constituted no more than a third of what a Dutchman band typically played. There were also waltzes, ländlers, schottisches, two-steps, and fox trots. A good Dutchman band needed to be able to cover the hits of popular dance bands, too, like Tiny Hill's "Angry" or Dick Jurgens's "Elmer's Tune." Moreover, on such numbers, the tuba player needed to be able to switch to string bass for an authentic "modern" sound.[37]

Dutchman bands in southern Minnesota have retained a very stable style to the present day, firmly within the canon of the most influential bands, Whoopee John and the Six Fat Dutchmen. In western Wisconsin, however, Dutchman music evolved to feature a more syncopated, jazz-influenced sound. In La Crosse, Syl Liebl, the musician Karl Hartwich saw as a boy, displayed one of the most freewheeling, improvisatory styles of Dutchman concertina playing, with his band, the Jolly Swiss Boys. Syl inspired a new generation of young players in the 1970s and '80s who took his improvisatory tendencies to still greater heights. Players like first cousins Brian and Gary Brueggen, who were descendants of a long line of family-farmer musicians, and Karl Hartwich, who the Brueggens reckoned might be their distant cousin, revolutionized

Francis McMahan, playing piano on the right, was bandleader of the Shamrock Band, a popular old-time band based in Madison, Wisconsin. Here they're playing in October 1955 at the Club List Ballroom, between Madison and Sun Prairie. The band regularly appeared on WKOW-TV's *Dairyland Jubilee* in the early 1960s.
Courtesy of
Francis McMahan

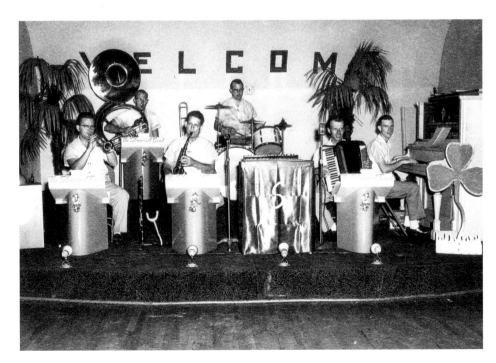

Bandleader Karl Hartwich of Karl and the Country Dutchmen, from Trempealeau, Wisconsin, July 2013

Dutchman music. They built on Syl Liebl's style, adding musical elements from vintage jazz, such as strongly accented off beats, syncopation, and chromatic runs. Perhaps these jazzy notions were inspired by the bands from New Orleans that traveled to the area on Mississippi riverboats, influencing musicians like the eminent early jazzman Bix Beiderbecke, from Davenport, Iowa, close to Karl's birthplace in Moline, Illinois.

Although jazzy, this music is nonetheless rural. Western Wisconsin's rural nature is reflected in local bands' names: Brian and the Mississippi Valley Dutchmen, Gary and the Ridgeland Dutchmen, and Karl and the Country Dutchmen, to name just a few. Even the names of some of their original songs evoke the countryside: "Brush Creek Laendler," "Pine Hollow Schottische," and "Bird Nest Polka."

Although he grew up in the 1960s and '70s on his family's farm in Illinois, Karl never cared for farm work. While driving a tractor to cultivate a field, he would press out the concertina fingerings for a tune that was running through his mind on the vibrating metal of the toolbox beside his seat. At age twelve he persuaded his mother, Norma, to buy him a concertina. At age thirteen he formed a small combo to play for local dances, with Norma backing him on tuba. By the early 1980s, Karl's innovative playing had become all the rage on the Dutchman scene. Around that time, an old-time concertina player who hadn't seen Karl play live, erroneously insisted to me that Karl must have put some extra buttons on his instrument, because it "just wasn't possible" to play the music Karl produced on a normal concertina.

Not only has Karl developed a new way to play the old songs, but he has composed several tunes like "Christmas Toy" and "Mud Puppy Polka" that have become important additions to the Dutchman canon. Similarly, the Brueggen cousins have created plenty of new tunes as well.

But, as Karl and the Brueggens were expanding the musical possibilities of the Chemnitzer concertina and the Dutchman style, its core audience was dwindling, and the commercial viability of operating a Dutchman band began to shrivel away. By the 1990s I heard frequent comments from followers of Dutchman and other polka styles, expressing concern about the need to attract more young people to old-time dancing. Most of the children of Dutchman enthusiasts born since the 1950s have drifted away from the style. Efforts to attract new followers have had very limited

success. In the 2000s, the pace of decline has quickened, especially in the Dutchman and Bohemian styles.

As a former bandleader, Francis McMahan likes to discuss the business aspects of old-time music. Francis plays in my Down Home Dairyland Band; on the way to a recent gig, we had a conversation about the topic. I mentioned that Dick and I had done a photo shoot at a dance featuring Becky and the Ivanhoe Dutchmen at Turner Hall in Monroe. Francis's band had played at Turner Hall dozens of times, and he still plays there occasionally in another group.

"How many people were there?" Francis asked me.

"About one hundred fifty," I told him.

"Well, that's about as big a crowd as they get there anymore," Francis said. "I remember we used to get four hundred to five hundred, and one New Year's Eve we sold a thousand tickets—that was our biggest crowd there ever."

He asked about the age of the attendees, and I confirmed that virtually all of the dancers were in their sixties or seventies, some even older.

Because fewer paid admissions means less money for the band, it's rare these days for Dutchman bands to work with a full complement of seven or eight pieces. Becky had a pruned-down lineup of five at the Turner Hall dance, and often she works with just a trio or duo. Unable to cover the costs, quite a few bands have ceased operations. Karl can see the writing on the wall. For a while he pondered a career in aviation, but after forty years of playing, he has decided to stick with music for now. "I figure enough of it [the Dutchman music business] will last for the rest of my life," he told me.

Although its decline is regrettable, Dutchman music has had longevity. The genre had its early beginnings even before Whoopee John's first recordings in 1926. Nearly a century later, it is still going on. Few musical genres have sustained their popularity that long. The legacy of the music produced over the decades is everlasting. Dutchman recordings have been conserved by amateur collectors, and at least one professional academic archive, the Mills Music Library at the University of Wisconsin–Madison, preserves Dutchman recordings along with a wide range of other midwestern music traditions.

While Dutchman's commercial potential is shrinking, it seems unlikely to die out completely. Rather it is becoming the province of a smaller in-group of enthusiasts. They find each other on the Internet and gather from far afield at the festivals. Outstanding younger players like John Dietz and Ryan Herman have taken an interest in the music, and some younger people are discovering the pleasures of couple's dancing. And, as we'll see at Pulaski Polka Days in the following pages, many younger Dutchman fans are gravitating to bigger events in other polka styles that have remained more vital, especially the Polish American polka scene.

Dutchman-style Polka

Opposite
Members of Becky and the Ivanhoe Dutchmen, including Becky's husband Terry Ard on the left and Don Elmer on the right, performing at Turner Hall in Monroe, Wisconsin

Pages 80–81
(left) Ted Neveln, tuba player for Becky and the Ivanhoe Dutchmen; (right) Barefoot Becky Livermore

Pages 82–83
(left) Dancers at Turner Hall; (right) Dancers at Laack's Ballroom in Johnsonville, Wisconsin

Pages 84–85
Members of the Hayes Boys Orchestra performing at Laack's Ballroom

Pages 86–87
(left) Dancing at Turner Hall; (right) Tony Kaminski, tuba player for Karl and the Country Dutchmen, at Zielinski's Ballroom in Pulaski, Wisconsin

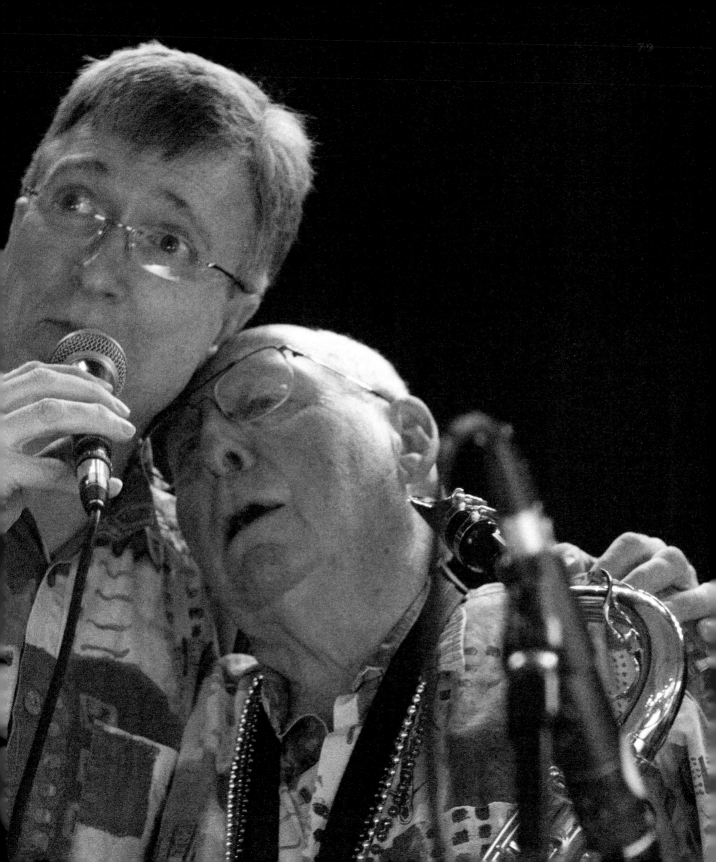

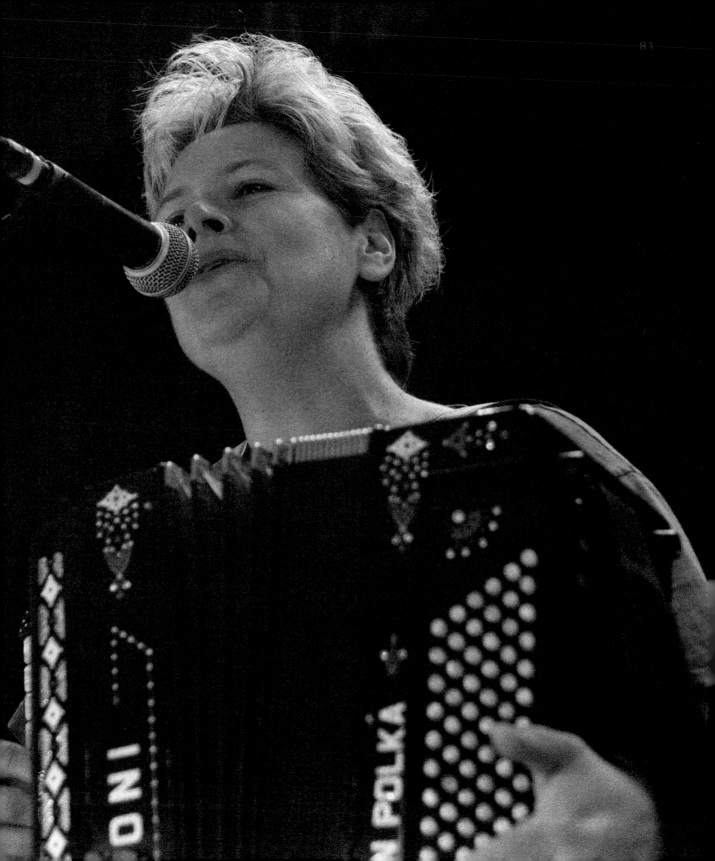

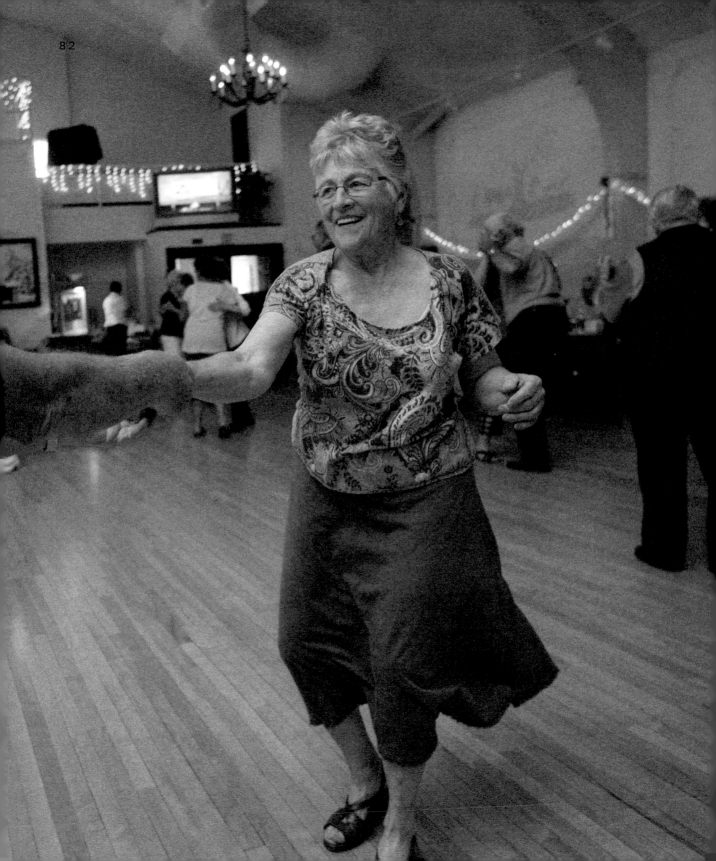

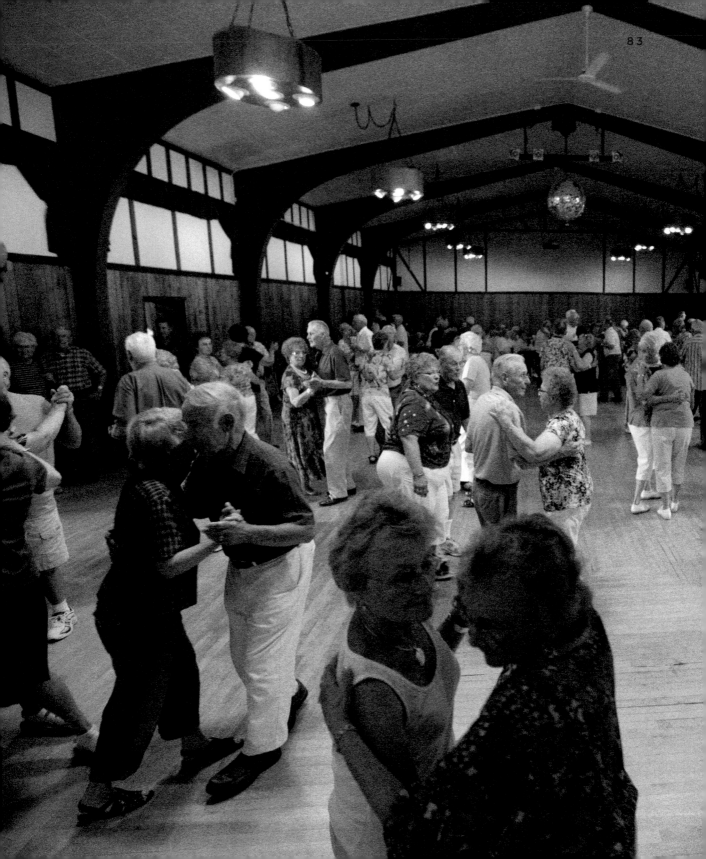

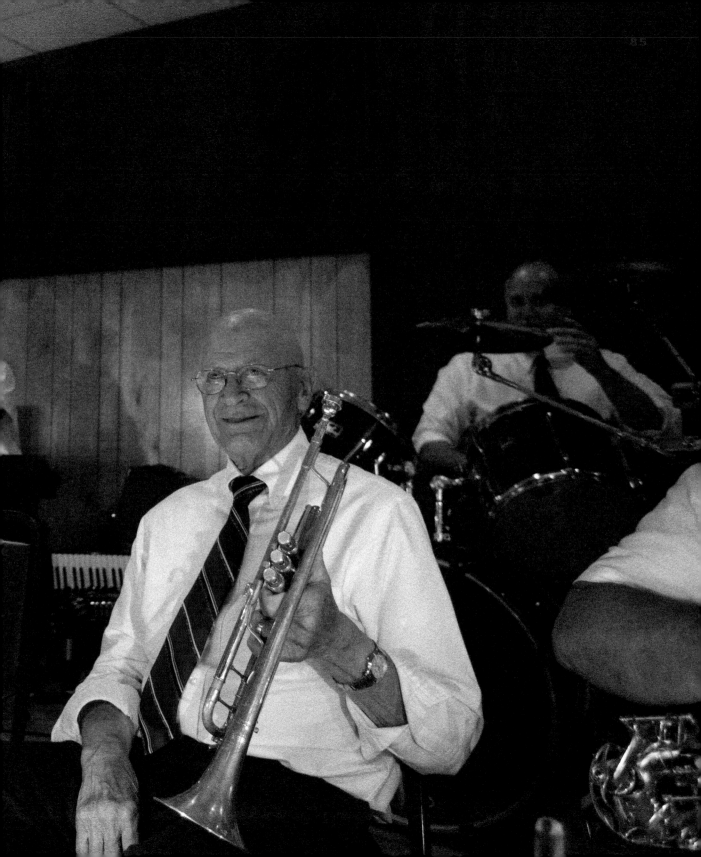

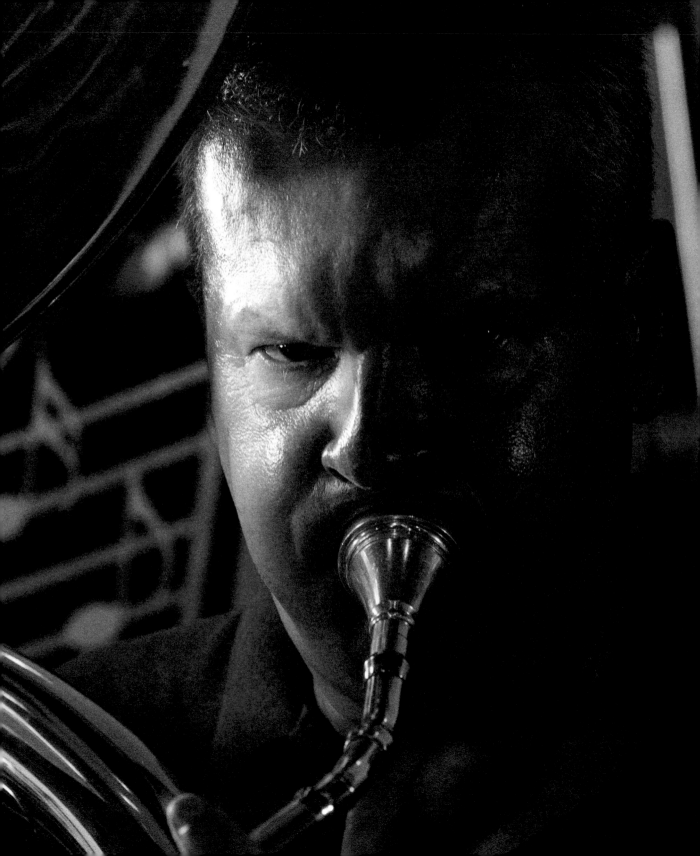

POLKA INTERLUDE

Concertina Millie Kaminski

Concertina Millie Kaminski is coy about revealing her age. "What you don't know won't hurt you," she usually says when journalists, friends, or fans ask her. But with a little arithmetic it's not hard to calculate that Millie must have been nearing ninety years of age on the frosty Saturday afternoon in February 2013 when I picked her up at her home in Muskego, Wisconsin, for the short drive to Martin's Tap, a roadside tavern in New Berlin. I loaded Millie's concertina and a small suitcase with her other gear into the car.

We were joined by Marie Stickler, an ethnomusicology student from Vienna, Austria. I was shepherding Marie around Wisconsin and Minnesota to meet Chemnitzer concertina players, the subject of Marie's thesis. And I thought she should meet the woman known as Concertina Millie.

When I called her to arrange the meeting, Millie proposed we get together at Martin's Tap. I called bar owner John Martin to let him know we were coming.

"Can I let some other musicians know about this?" John asked.

"Of course," I told him.

Martin's Tap is a hole-in-the-wall bar added onto the front of a small residence on National Avenue, once a main highway leading out of Milwaukee. When John Martin's parents built the bar, it was on the edge of town; but in the decades since, rings of new suburbs have sprouted to its west and south. A classic Pabst Blue Ribbon bar sign hangs from a pole in front, and a small, yellowing

Concertina Millie Kaminski playing at Martin's Tap

POLKA INTERLUDE

poster in the window proclaims, "Polka is Wisconsin's Official State Dance."

As soon as we arrived, several other cars pulled into the parking lot. Before long, half a dozen concertina players were unloading their instruments and heading

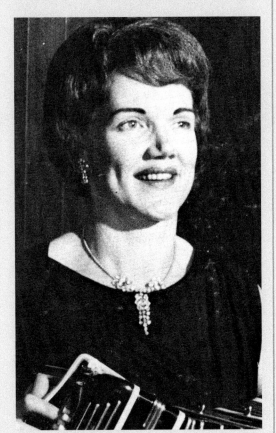

A young Concertina Millie
Courtesy of Cuca Records

into the bar. Even on short notice, the opportunity to play in an intimate music session with the legendary Concertina Millie was a magnetic draw for players and enthusiasts of her kind of music.

Millie was born in Milwaukee in the 1920s. Her father played the bandonion, a slightly smaller variety of concertina named after its nineteenth-century German inventor, Heinrich Band. In grade school, Millie learned to toot on a harmonica and began learning how to play her father's bandonion. When Millie was twelve years old, her mother passed away, so she quit school to help her father and two brothers. At age sixteen she managed to get her own concertina, but she only had the luxury of six lessons. "That was during the Depression when there was no money," she told me, "so I had to learn by watching other people play."

When she was still a teenager, Millie became, to her knowledge, the first female to professionally play a concertina in Milwaukee. She told me about an early gig. The United States had entered World War II, and many of the male musicians had joined the armed services. As a young, musical "Rosie the Riveter," Millie was recruited to

POLKA INTERLUDE

play in a Milwaukee tavern. "I only knew how to play one number at that time, 'Elmer's Tune,'" she said. "They said, 'That's OK,' so I just kept playing it over and over."

Millie's repertoire quickly expanded. She has a strong singing voice and, along with polka and waltz tunes, she played and sang the popular songs of the day. During the war, she also worked in a factory, but found it "too monotonous."

"I would go to a tavern and play on Sunday afternoons," she told me. "I met loads and loads of people. I never could get lonesome at the time."

After the war, she met Ed Kaminski, one of the servicemen who came to the taverns where she played. A romance blossomed; they married in 1946, and the young couple moved to Muskego. Ed worked as a truck driver, and Millie played as many as five gigs a week. They had one daughter and were married for forty-six years until Ed's passing in 1992.

In the late 1950s and early 1960s, Millie appeared about twice a week on WTMJ-TV's *The Hot Shots,* an early Milwaukee TV show featuring local musicians and hosted by legendary radio and TV personality Gordon Hinckley. Here, right

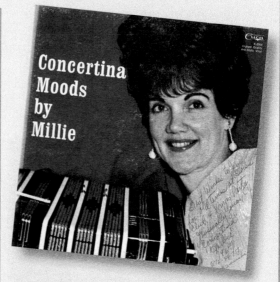

An early-1960s record cover from Concertina Millie
Courtesy of Cuca Records

before her first appearance, is where Millie got her stage name.

"About five seconds before we were going to go on," she said, "Gordon Hinckley asked me, 'What do you want to be, Millie and her concertina, or Concertina Millie?' So I quick said 'Concertina Millie' and that's been it ever since."

Her TV appearances attracted so much attention that Millie was offered the chance to play in a Broadway musical in New York City. Though she turned it down to stay home with her young daughter, Millie has

POLKA INTERLUDE

remained a dedicated musician on the Milwaukee musical scene for decades. "I get asked to play for weddings," she told me, "and they'll say, 'You played for my parents' wedding too.' Lately, I'm having to play for funerals, too."

Once inside Martin's Tap, Millie wasted no time. She found a seat on a vinyl-covered chair, spread a cloth over her knees, and cradled her concertina on her lap. Her squeezebox is elaborately decorated with shiny cellulose, and rhinestone-encrusted letters spell out "Concertina" on the left side and "Millie" on the right. Despite her years, Millie's style of dress and grooming reflect her long career as an entertainer, exhibiting the same flash as the concertina itself.

In an instant, as I had seen her do so many times, Millie started her show. Her hands pumped the bellows, fingers confidently pressing buttons, and when she started her animated singing, her voice was strong and clear, just as it always had been. Marie, the ethnomusicology researcher, was charmed, smiling broadly as she trained a small video camera on Millie. This recording of Millie's performance would be heading to Vienna.

Millie played about a dozen songs and instrumental tunes before yielding the floor to other players. Everyone wanted to hear the music of our guest from Austria, so Marie, who happened to be a gifted button accordion player, played and yodeled a couple Alpine songs. Gunter and Tony Langeweg, a father-and-son duo, squeezed out some Dutchman tunes, and Rich Raclawski, a tool and die maker who builds concertinas in his home workshop in his free time, graced us with solid, Li'l Wally-style Polish polkas on his own handmade box. A pair of elderly men dropped by from their assisted-living apartments; one of them, at ninety-three years old, borrowed a concertina and wrung out a couple of tunes of his own. Where it fit in, I provided rhythm with my tenor banjo; and from behind the bar, John Martin played along with his accordion.

The half dozen or so musicians took turns playing; about an equal number of listeners took in the music, sipping on cans of beer. We were very deep in the Chemnitzer concertina culture of Milwaukee. The wintertime afternoon yielded to darkness, and the session was coming to a close. We yearned that it could last forever.

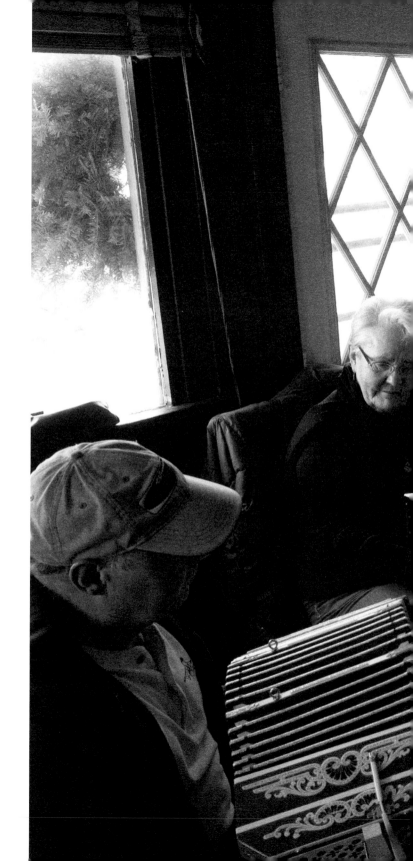

Concertina Millie Kaminski

Opposite
Musicians and fans gathered to see Concertina
Millie at Martin's Tap in New Berlin, Wisconsin.

Pages 94–95
Concertina Millie performs with the father-
and-son duo, Gunter and Tony Langeweg.

Pages 96–97
Rick Raclawski

Pages 98–99
Martin's Tap

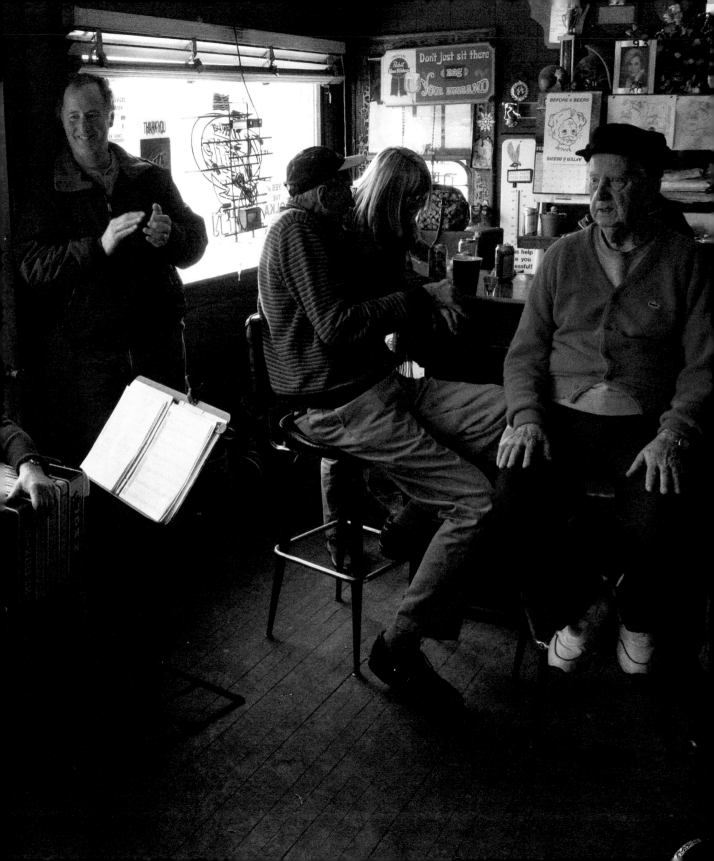

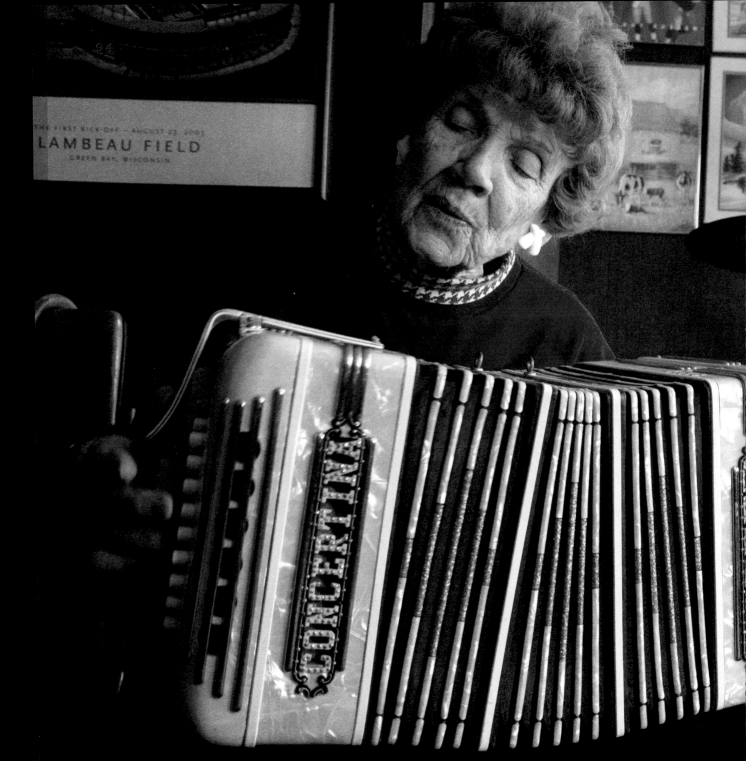

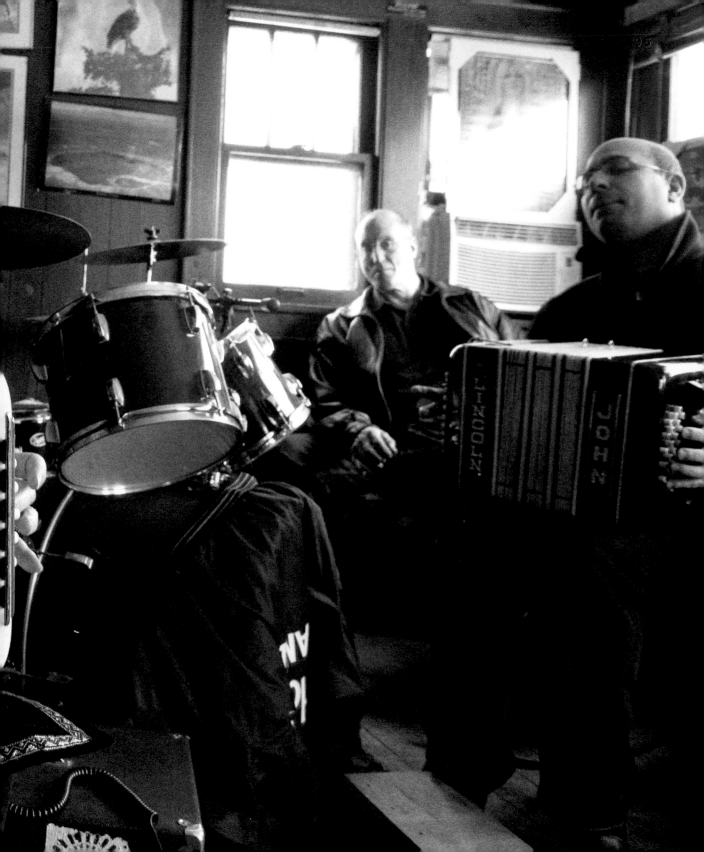

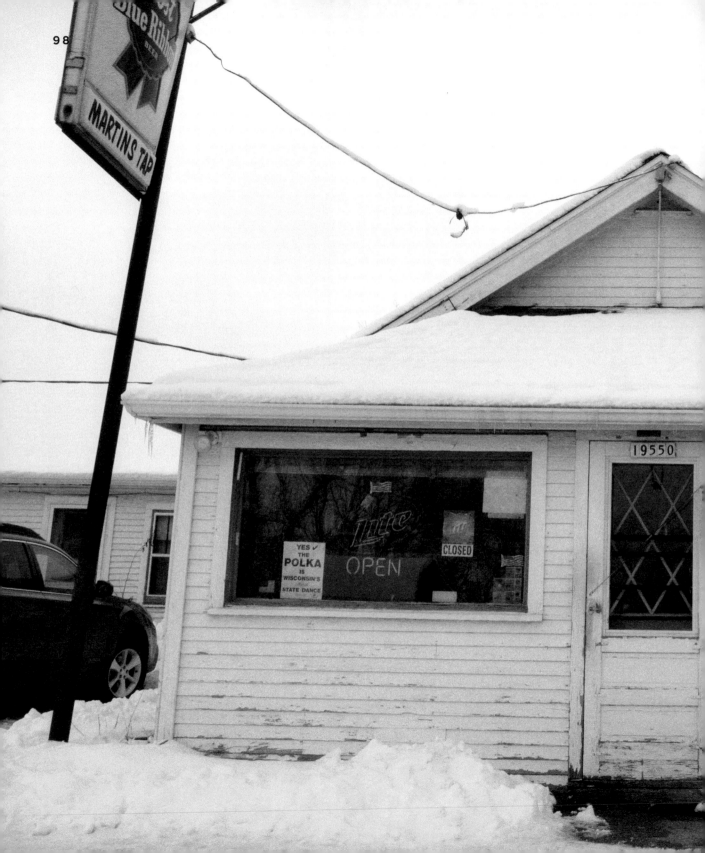

PULASKI POLKA DAYS

A well-known song by Alvin Styczynski begins, "Pulaski is a polka town." Indeed, there are few other places where the polka has made the kind of impact it's made here, in this small farming community northwest of Green Bay. Pulaski has produced great polka bands over the years; it seems like everybody in town knows how to dance; and, since 1978, the highlight event of the year comes in late July—Pulaski Polka Days.

Pulaski was not the original American home for the Polish immigrants who settled there. The land around Pulaski was low-lying, covered in brush and pine stumps. Beginning in the mid-1880s, a Chicago land developer named John J. Hoff decided to market this unpromising acreage to land-hungry Polish immigrants working in Milwaukee, Chicago, and other industrial cities. Many Polish immigrants, who had endured years of hard labor in American factories and mines, yearned for an opportunity to use their native farming skills to improve their lot. Hoff provided loans, tools, and food staples to Pulaski's settlers, who grubbed out stumps and dug stones from the fields, ultimately creating the flourishing agricultural area found there today.[38]

Its unique history distinguishes Pulaski from other rural, Polish American communities in Wisconsin, where the settlers came directly from a particular Old World region. For example, the Poles around Stevens Point are mainly Kaszuby from the Baltic Sea area in northern Poland, and the Armstrong Creek Poles are overwhelmingly Gorale from the Tatras Mountains in southern Poland. But the disparate Poles who carved out the farms in Pulaski came to the United States from many different provinces. They proudly united their new community under the name of Casimir Pulaski, the Polish general who was a hero of the American Revolutionary War.

Amanda Raflick and Adam Hembel dancing at Pulaski Polka Days

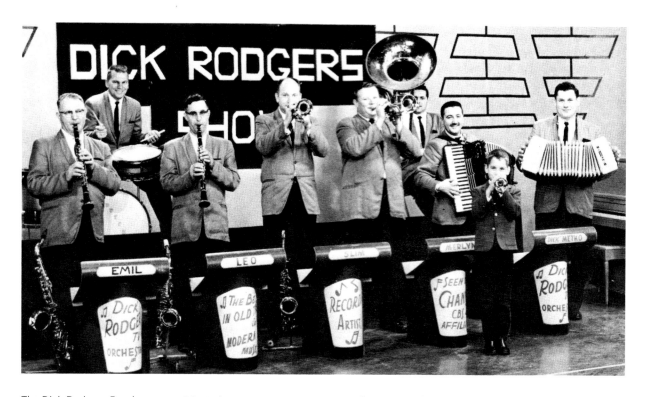

The Dick Rodgers Band in Green Bay's WBAY-TV studio in 1963

Courtesy of Dennis Brown

Music became an important amalgamating force in the community. Pulaski's first settlers included fiddlers, who were joined by players of the Chemnitzer concertina by the early 1900s. The Chemnitzer was invented in Saxony in 1834. German immigrants in Chicago imported and sold this type of concertina, and, beginning in 1917 with the arrival of skilled artisans, manufactured them in Chicago, too. Through happenstance, this German squeezebox had been eagerly embraced by the Chicago and Milwaukee Poles. The major concertina importers and manufacturers happened to locate in two predominantly Polish neighborhoods of Chicago: Otto Georgi began his operations in the 1880s in the Back of the Yards neighborhood; and about a decade later, Henry Silberhorn was selling and Otto Schlict was building concertinas in two businesses within a couple of blocks of each other in the Polish Milwaukee Avenue neighborhood on the near north side. Traveling concertina musicians like Max and Helmut Peters acted as salesmen; they made the rounds to rural Wisconsin German and Polish communities, offering these mighty squeezeboxes to farmers and townsfolk on an installment plan.

Musical influences also came to Pulaski from the nearby northeastern Wisconsin Czech bands. Indeed Dick Rodgers, the first Pulaski bandleader to achieve regional

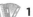

fame, played in the Bohemian style of the Czech bands and always included Czech sidemen in his orchestra.

Rodgers had anglicized his Polish surname, Rodziczak, a common show-business practice in that era. He established his band in 1945 when he was still a high school student. By the late 1940s, Rodgers's band was touring the region, making records and playing on live radio from Marinette, Wisconsin. Rodgers generally led the band from the piano, playing occasional concertina solos. In 1958 he recruited a key sideman, accordionist Dick Metko, who hailed from a small Ukrainian community in Wisconsin's north woods. Metko had a freewheeling, improvisational style. His zany accordion licks lent a madcap feel to the Rodgers band's sound.

Rodgers began television broadcasts in 1955, initially from Marinette, and later from the larger media market of Green Bay. The weekly *Dick Rodgers Show* remained on the air for twenty-three years, until 1978.

The Bohemian sound remained popular in Pulaski, but by the later 1950s, the Chicago style of Polish American music began to penetrate the Wisconsin polka scene. This music's leading early pioneer was Walter Jagiello. Born in Chicago in 1930 to Polish immigrant parents, Walter was a musical prodigy who began singing at Polish picnics at age eight, thereby acquiring his lifelong show-biz moniker Li'l Wally (or *Mały Wladziu* in Polish).[39]

Li'l Wally Jagiello performing at the Strand Ballroom in Buffalo, New York, ca. 1973

Wally learned drums and concertina, and at the age of only fourteen, he became the leader of his own band. In his combos, Wally offered a down-home style of Polish American music heavily influenced by his southern Polish Gorale roots. He pioneered a small combo sound nicknamed "honky style," featuring a trumpet, concertina, and drums as the core of the band, adding a clarinet or string bass at bigger gigs. Wally's singing in Polish and English was an important part of the music. Additionally, Wally favored a slower tempo, which made it possible for dancers to execute a newly popular polka dance step called the "Polish hop," which is danced in double time to the music.

After a brief stint as a Columbia recording artist, Wally started his own Jay Jay label in 1951 and began to record prodigiously, releasing scores of albums in his sixty-year music career. For decades he toured widely through what is known as Polonia, the American Polish ethnic communities in the Midwest and East, and he continued touring Polonia even after he moved to southern Florida in 1965.

Following in the footsteps of Li'l Wally came Eddie Blazonczyk and his Versatones, the next band to have a big influence on Polish American polka. Eddie was the originator of a style known as "Chicago push" or "dyno." Eddie was born in Chicago in 1941, like Li'l Wally a son of Polish immigrants. In Chicago, Eddie's father operated the Pulaski Ballroom and the Mountaineer Bar, where as a boy Eddie heard Li'l Wally and other leading polka musicians like Steve Adamczyk and Marion Lush.[40]

After a brief career in rock 'n' roll, during which he toured with Buddy Holly, Gene Vincent, and Brenda Lee, Eddie decided in 1962 to devote his efforts to polka. He updated the polka sound by borrowing from his rock experience a strong electric bass guitar and stressing the concertina, clean trumpet lines, and a hot rhythm, enhanced by a bellow-shaking accordion. Eddie's powerful baritone voice was crucial to the sound of the Versatones. And like Wally, Eddie established his own independent record label,

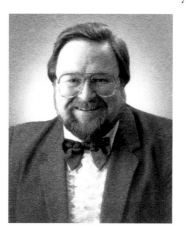

Eddie Blazonczyk, ca. 1980

Courtesy of Bel-Aire Enterprises

Bel-Aire, to record and market the music of his own band and other polka musicians.

The Chicago sound came north to Wisconsin and has subsequently spread to Polish American communities from coast to coast. Bandleader Norm Dombrowski from Stevens Point recalled Li'l Wally's first big gig in central Wisconsin in the late 1950s. Crowds packed the ballroom and even more people surrounded the building just to listen. Norm formed the Happy Notes Orchestra in 1960, playing in Wally's "honky" Polish style. With Norm's sons and daughter as its core members, this family band

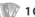

Eddie Blazonczyk's band, the Versatones, parodied a Beatles album cover in 1965, at the height of Beatlemania.

Courtesy of Bel-Aire Enterprises

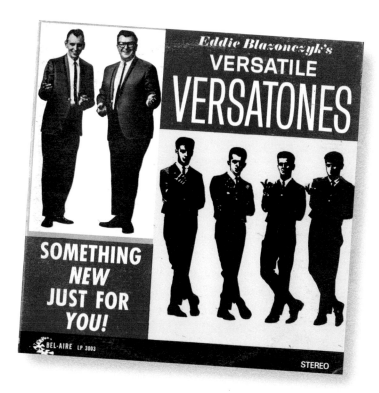

remains active today, even subsequent to Norm's passing in 2013. Also in the early 1960s, in Pulaski, Alvin Styczynski started a band in the same "honky" style. Alvin's outfit likewise continues to play today.

In 1978, about the time Dick Rodgers was beginning to ease off in his musical efforts, a broad coalition of Pulaski community groups, including the Volunteer Firemen, the Future Farmers of America, civic clubs, and various veteran's organizations, initiated Pulaski Polka Days, a four-day polka festival that has turned into one of the state's most beloved cultural events. The event embodies Pulaski's long tradition of appreciating the diverse strands of the polka-loving world. Polish bands from around the country play there each year, as well as Bohemian and Dutchman bands. Even Frankie Yankovic performed in Pulaski with his celebrated Slovenian style.

Top bands from across the nation always appear at the festival, but local groups from Pulaski and other nearby towns are the mainstay. Pulaski's Maroszek Brothers have performed at every festival since the first Polka Days in 1978. Moreover, every year they play the Polka Mass, a liturgical service featuring polka music, which has been integral to the event from its beginning. By the late 1990s, the Maroszeks' children started their own band, called New Generation, and have become Polka Days regulars.

Other Pulaski bands such as those of Chad Przbylski, Aaron Socha, Roger Majeski, the Polkatown Sound, and Alvin Styczynski put a strong local stamp upon the program.

During Polka Days, the whole town is gripped with polka fever—from the Polka Trot 5K run and the crafts fair that offers Polish and polka-themed wares, to polka dancing at local bars and a dance contest featuring music by Bohemian and Dutchman bands in Zielinski's Ballroom, an old-fashioned dance palace on Main Street. But the really big deal is at the local park where two massive tents are put up, each fitted with a stage wide enough for two band set-ups and a spacious wooden dance floor, sprinkled with wax flakes to offer plenty of glide to the many skilled dancers doing the Polish hop.

When Dick and I attended the 2013 festival, we found that from noon until nearly midnight, dancers could choose between two Polish-style polka bands in the park, or head down the street to Zielinski's to dance to *oom-pah* music in the ballroom, where Karl Hartwich was one of the featured players. Local volunteers were busy collecting admissions, running concessions, and emptying trash barrels, and lots of other local people showed up just to dance. But the vehicles in the parking lot and the RV village revealed that Polka Days draws enthusiasts from afar. Dick and I saw plenty of out-of-state license plates, many from Illinois and Minnesota, but also significant numbers from Nebraska, Michigan, Indiana, Ohio, and Pennsylvania.

Ask any polka enthusiast about Pulaski Polka Days, and what he or she is likely to mention as most notable is the wide range in ages of the participants. The grounds were full of middle school, high school, and college students. Many of these young people skillfully danced rapid laps around the floor, as fleet as gazelles. Then there were young parents, out on the floor bouncing a toddler on an arm or teaching a grade schooler the basic steps. Many of the children wore hearing protection headphones, because the music at Polish American polka events tends to be really loud. Eddie Blazonczyk, a former rocker, brought rock-volume levels into the polka scene in the 1960s. There's no doubt the booming music appeals to younger people and has helped to keep them interested in this form of polka music.

Many of the younger and middle-aged fans now experience the bands more in the manner of a rock audience. Especially when the national polka stars were performing, a thick group of fans clustered in front of the stage, recording videos on smartphones or pumping their fists and shouting "go, go, go," in time to the music. And performers like Hank Guzevich from Pennsylvania, Stephanie Pietrzak from Buffalo, and Ed Siewiec from Detroit are well worth watching.

Hank's band still carries the name Polka Family, though he is the last of his family in the group. The band started in the 1970s in Southern California where his Polish American father and Mexican American mother met and married, then raised a crop

Stephanie Pietrzak, who goes by the professional name "Stephanie," performing at the Strand Ballroom in Buffalo, New York, ca. 1973

of musician children for the Polka Family band. They relocated to Pennsylvania to be in the heart of polka country. Hank emerged as the star of the band with his tall stature, striking stage presence, masterful trumpet playing, and impassioned vocals. After his parents passed away and his siblings drifted from the band, Hank recruited fine sidemen and continues to thrill polka audiences.

Stephanie Pietrzak also grew up in a family polka act, called Wanda and Stephanie, playing the concertina and singing duets with her mother, a rare female act in the male-dominated polka scene. Based in Buffalo, New York, Wanda and Stephanie achieved fame in the polka world for their solid, honky-style music and their 1960s hit "Lover Oh Lover." Stephanie has continued to tour since her mother's passing, and

Album cover for Patrick Nowak, known as Little Patrick the Polish fiddler

Courtesy of Bel-Aire Enterprises

through the decades she has achieved a level of soulful interpretation of the old Polish material few can match.

At the 2013 Pulaski Polka Days, Stephanie seized the chance to recruit musician Patrick Nowak for an upcoming recording session. As a preteen, Patrick played violin in his father Leonard's band in Omaha, Nebraska. He became known as Little Patrick the Polish fiddler. In the late 1970s, at age ten, he was the featured musician on an LP released by Bel-Aire Records. He proudly posed with Eddie Blazonczyk in a photo on the back of the album jacket. After a long hiatus from the polka scene, Patrick was back again in Pulaski where Stephanie spotted him.

Stephanie had recently visited Poland, where she encountered Gorale musicians playing their violin-based polkas in the south of the country. Struck by the music, Stephanie became determined to record Gorale songs and wanted to add the music's characteristic violin to blend with her concertina. Patrick was apprehensive, but Stephanie urged him to take out his fiddle and give it a go. Right there, in front of the Polka Days audience, they played together for the very first time. Much to everyone's delight, the musicians clicked. The crowd called for more and more. By the time they finished their set, Stephanie was asking Patrick just when he could make it to Youngstown, Ohio, to record with her in her favorite studio. It's the kind of thing that can happen in Pulaski.

By Saturday night, the polka mood had built up to a crest. Behind the backs of the fans clustered in front of the stage to watch Hank Guzevich, the most devoted dancers were whirling around the floor in the mysterious summer evening light beneath the tent's few incandescent bulbs. They included renowned dancers like Randy Thull and his wife, Ashley, hardcore promoters and active teachers of polka dance. Randy still plays in his family's band, the Goodtime Dutchmen, but he and Ashley are happy to spin and twirl to the Polish-style music at Pulaski. The floor full of dancers displayed personal creativity in motion. It was stunning, ranging from flamboyant drive to restrained dignity.

If some polka events seem faded in their glory, making one fear for the future of the tradition, at Pulaski Polka Days one is struck by its ongoing vitality. Musicians, dancers, and fans of every age gather here from far and wide, urban and rural. The Polish American polka is the standard-bearer, keeping polka vital into a new century.

Patrick Nowak and Stephanie Pietrzak jamming at Pulaski Polka Days

Pulaski Polka Days

Opposite
A sign for the 5K run near Pulaski in honor
of Pulaski Polka Days

Pages 112–113
The west entrance to Pulaski Polka Days,
before the crowds arrive

Pages 114–115
Stephanie Pietrzak, who goes by the stage
name "Stephanie," playing her concertina in
one of the band tents

Pages 116–117
Hank Guzevich and his sidemen, of the
Polka Family band

Pages 118–119
Revelers at Pulaski Polka Days

Pages 120–121
One of two dance tents, where crowds
gathered late into the evening

Pages 122–123
Polka Days east entrance

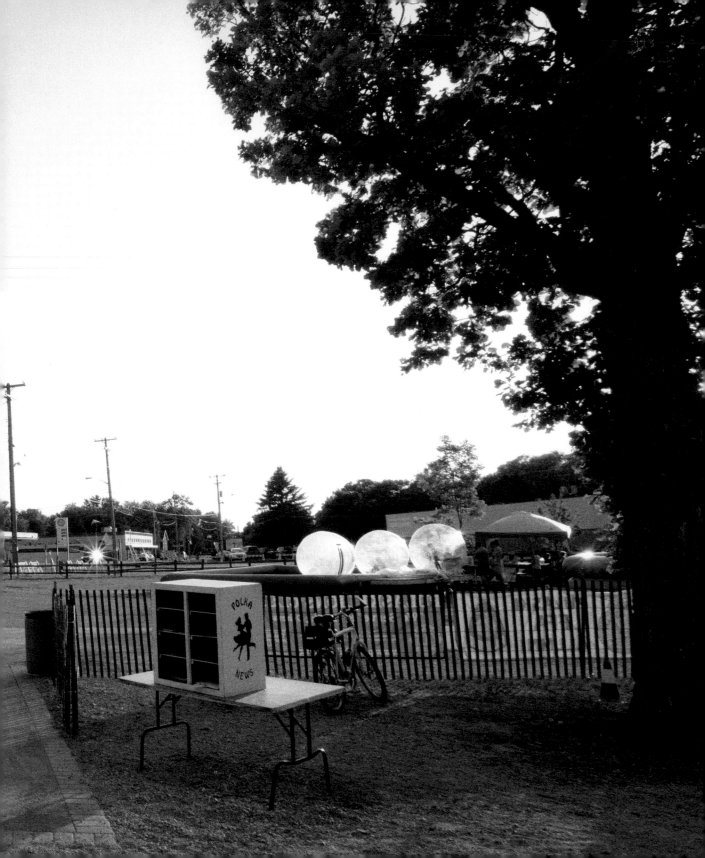

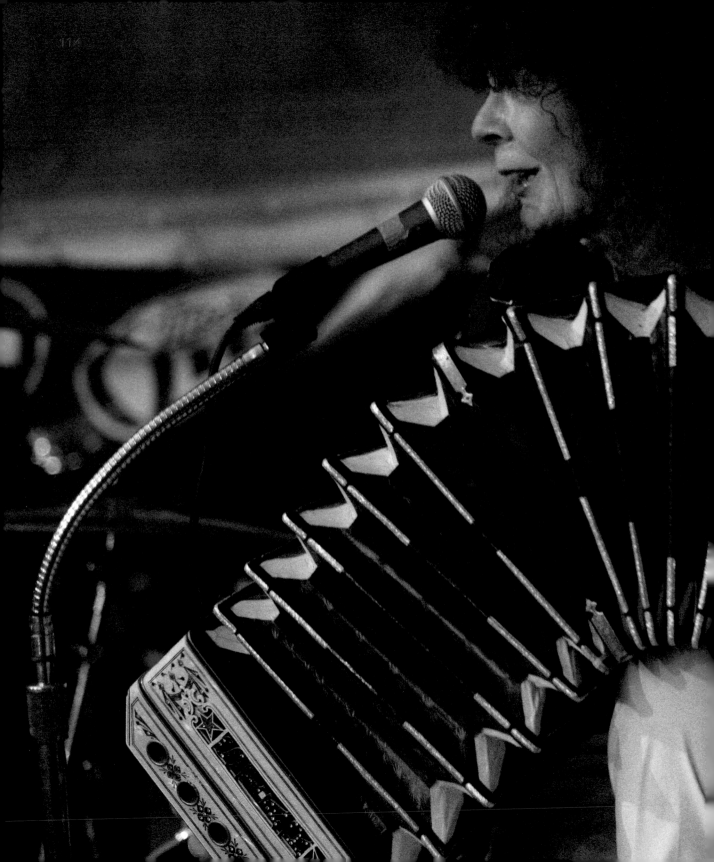

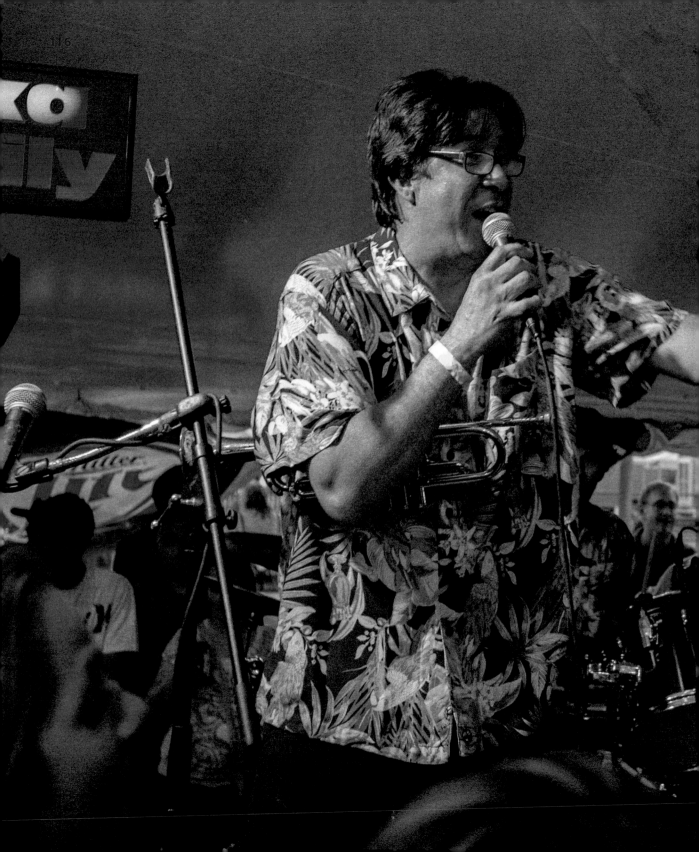

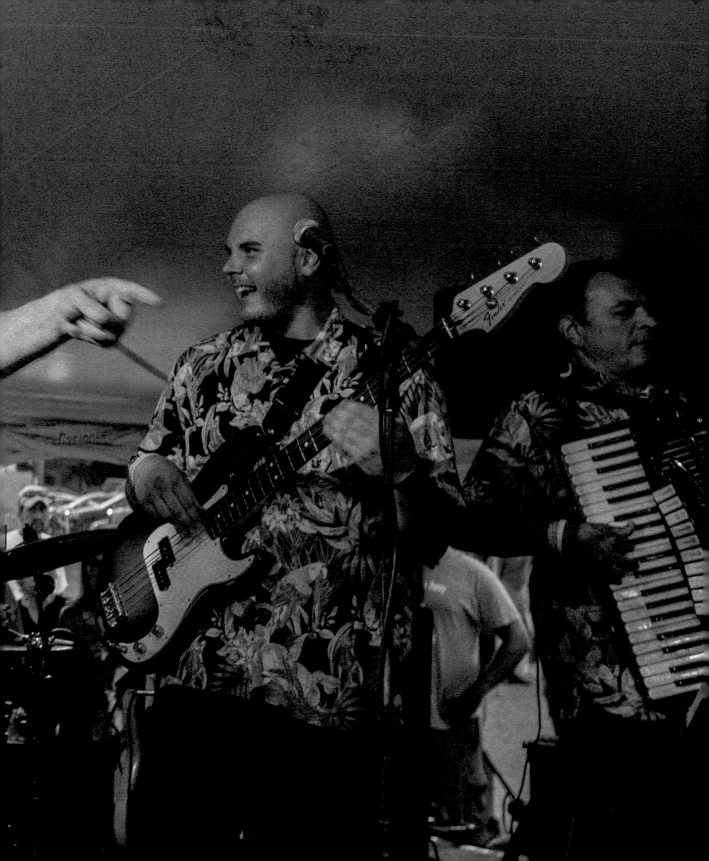

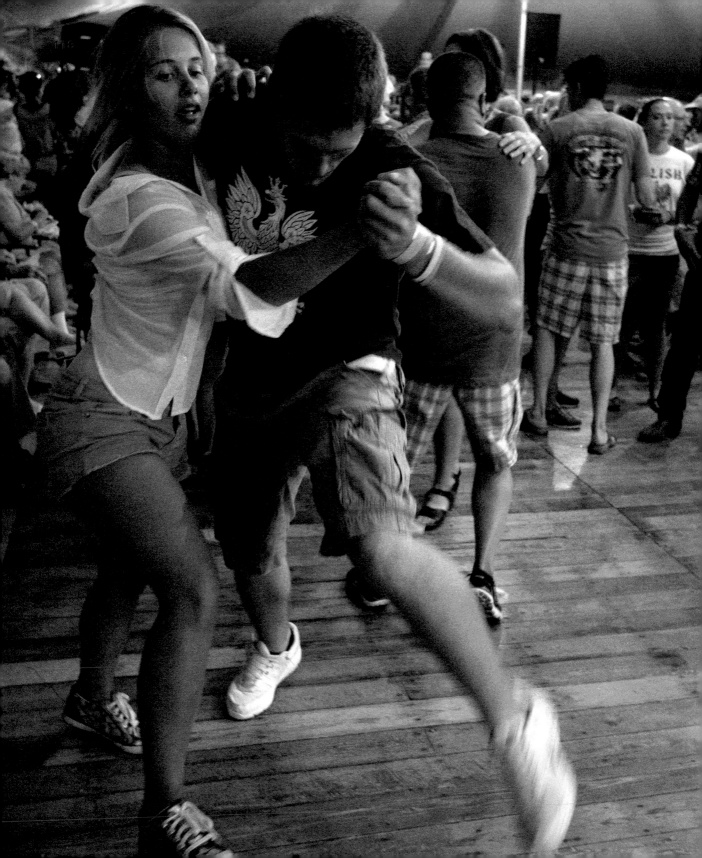

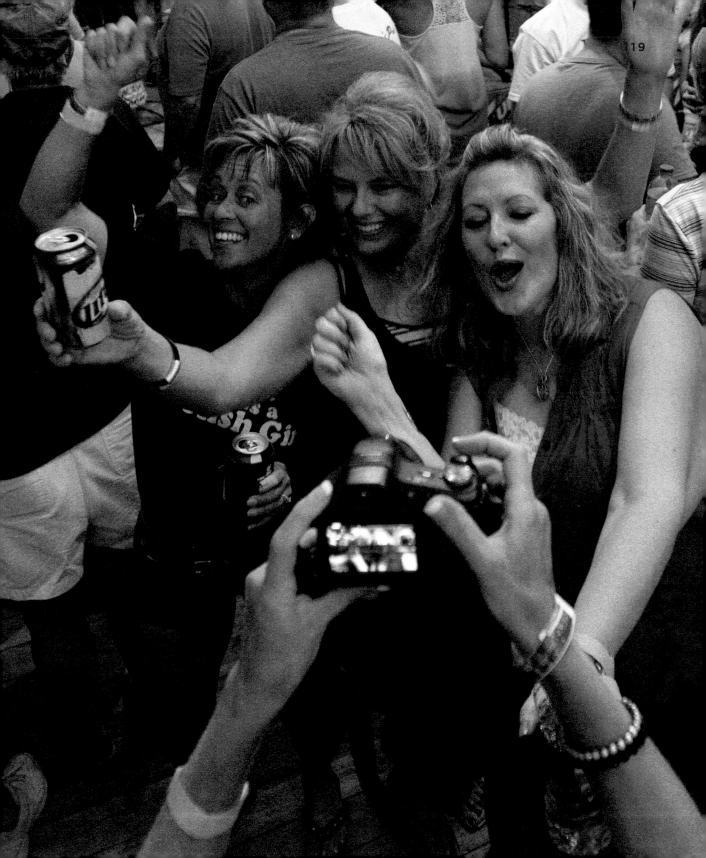

HOME OF
PULASKI POLKA DAYS

The Polka Mass

On a frosty Saturday afternoon in January in Kewaskum, Wisconsin, Father Edwin Kornath made his way from the Holy Trinity rectory out to the Amerahn Ballroom on the north edge of town. From his car, he pulled a rolling suitcase, which he dragged behind him through the bar and into the ballroom. The sarcastically named Heat Wave Polka Festival was going on. Shortly after Father Ed's arrival, the music and dancing paused; a long folding table was set up in front of the stage where the Goodtime Dutchmen, a local family band, was preparing to play for the Polka Mass. Song lyrics for the Mass were being passed out, in stapled booklets on goldenrod-colored paper.

Father Ed removed his overcoat to reveal clerical robes, then unzipped his suitcase and removed chalices, wine, and Communion wafers. He set up plastic, battery-operated candles. Soon the service began. Most of the dancers now were seated at the tables along the ballroom walls, singing the songs and following the order of service noted in the goldenrod booklets.

I had seen many a Polka Mass. Since the 1970s they have become an accustomed feature of larger polka events, and many parishes in the Midwest celebrate them for other special occasions. The Polka Mass is a beloved form of worship for many. And yet, the Polka Mass has always been controversial. From its beginning it's had strong proponents who find it a meaningful way to worship, as well as severe detractors who ridicule it and considered it blasphemous, including some members of the Catholic Church hierarchy.

Regarding the appropriateness of the Polka Mass, Father Edward McNamara, professor of liturgy at the Pontifical Athenaeum Regina Apostolorum in Rome stated that according to liturgical principles, "music usually associated with dancing or other profane activities" is not suitable to be played during Mass. Father McNamara voices his stern disapproval in more measured words than some other detractors. Matt Korger from La Crosse, Wisconsin, who blogs online as "Badger Catholic," wrote, "It would be better to be

POLKA INTERLUDE

shot than to have to sit through the aptly named Polka Mass." His statement set off a chorus of intense comments on his blog, with some people calling the Polka Mass a "nightmare," "illicit," and "liturgical abuse."

"It is wrong on so many levels, and not just because it's tacky and dated," wrote one commenter. Another person wrote, "Have your polka music in the beer tent, drink up, have a good time, but keep it the hell outta Church!!"

No proponent of the Polka Mass has more successfully countered such criticisms

Father Frank Perkovich's Polka Mass album, released in the 1970s
Personal collection of Rick March

than Father Frank Perkovich, who is widely credited as its founder and most significant popularizer. Father Frank was born in 1928 in the town of Chisholm, on northeastern Minnesota's Iron Range. His iron miner father came from Croatia, his mother from Slovenia. Frank grew up immersed in the culture of his working-class immigrant community, speaking Croatian and Slovenian as well as English. His family was very musical. Frank's brother John was an accordionist, and at family gatherings they sang Slavic folk songs.

Frank was ordained in St. Paul in 1954. He served his entire clerical career in parishes in his home region. He spent his longest stay of twenty years in Eveleth, about twenty miles east of his hometown.

In a 1990 oral history interview, Father Perk (as Frank was nicknamed) explained the origin of the Polka Mass and its significance:

The first Polka Mass was held on May 5 in 1973, at Resurrection Church. What is the Polka Mass? Well, the Polka Mass consists of the same basic worship service celebrated in the Roman Catholic tradition but utilizing

a unique mode of music. Folk music, cherished by generations of Slovenian and Croatian and Slavic people, has been specially arranged and adapted with hymn lyrics in English. The old ethnic melodies are presented in the polka of the Joe Cvek band . . . and are sung in reverence by the congregation and by the choraliers, which I later named the "Perkatone" singers. The result is a joyful, inspiring worship service with the most unusual music, presented in a manner of dignity which enhances the solemnity of the Mass. Why did I start the Polka Mass? Well it started by reading the Vatican Counsel. And the bishop's committee on liturgy noted that the music in Mass should suit the age level, cultural background, and level of faith of the worshippers. . . . Polka and waltz music form some of the cultural background of many groups of people who form a worshipping community. And so the use of this music combined with appropriate words can make a religious service more personal and meaningful for those participating.

People in the polka-loving communities generally concurred. The idea spread and scores of polka bands in numerous American regions developed their own versions of the Polka Mass. In many areas, Protestant services utilizing polka music have been developed. While many parishes in polka country organize a Polka Mass for a special occasion or during a church festival, perhaps its most frequent celebration is during multiday polka festivals. The services have become a beloved component of these events and commonly are held on Sunday mornings, usually right on the dance floors.

Back in the Amerahn Ballroom in Kewaskum, Father Ed was leading the crowd through a liturgy that used newly composed religious lyrics to familiar polka melodies. Father Ed began with the reminder that worship of this sort belonged where the people were, in the community, right here in the ballroom. Then he recounted an anecdote from his childhood. He grew up in the 1960s in the heart of a Polish neighborhood on Milwaukee's near-south side. His mother was an avid polka enthusiast. Every morning, she played loud, lively polkas on the record player to wake

POLKA INTERLUDE

her children up for school. One snowy winter morning, young Ed trudged the few blocks to his nearby Catholic school only to find the building locked up. There had been a big storm the night before and school was canceled. He trudged home.

"Mom, you should wake us up with the clock radio instead of the polka records. Then we'd hear when it's a snow day," he told her.

"Well, okay, maybe, only on snowy days," she said, "but otherwise, it's still going to be the polka records."

Father Ed's homily is a perfect illustration of how much the polka is integrated into the everyday life and culture of polka-loving communities. And the Polka Mass is something many in these communities appreciate.

The Polka Mass

Opposite
Dancers at Amerahn's Ballroom in Kewaskum, Wisconsin, enjoy some Polish sausage during the break between the band performances and the Polka Mass.

Pages 130–131
(left) Father Ed performs the Polka Mass; (right) Xavier Dietz, son of musician John Dietz, watches his dad's band play.

Pages 132–133
Dancers pause to snap a photo of John Dietz, a concertina and tuba player from Slinger, Wisconsin, performing with the Barry Boyce Band.

Pages 134–135
(left) Ryan Thull, with his accordion; (right) Randy Thull and his sister, members of the Goodtime Dutchmen, which played for the Polka Mass

Pages 136–139
Dancers at Amerahn's Ballroom, including Randy Thull and his wife Ashley, p. 136

Dinner Specials
In Main Bar @ 5pm

Pulled Pork Sandwich $3.00
 with potato Salad $4.50

Chicken Sandwich $3.00
 with potato Salad $4.50

Polish Sausage $3.00
 with potato Salad $4.50

Pork Sandwich $3.00
 with potato Salad $4.50

Dessert $2.00

Coffee $1.00 (1 free refill)

BUD
LIGHT

OPEN

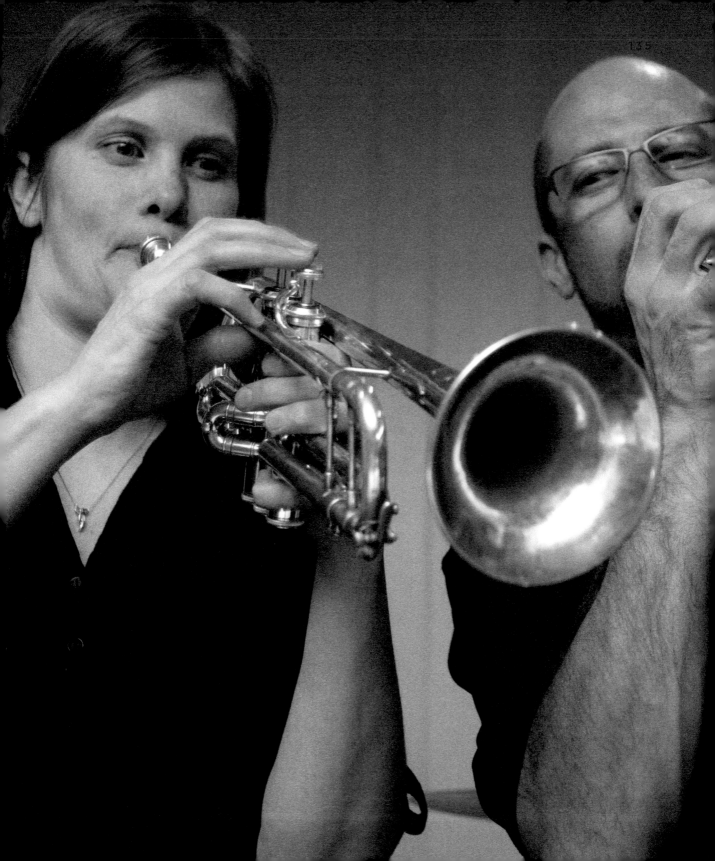

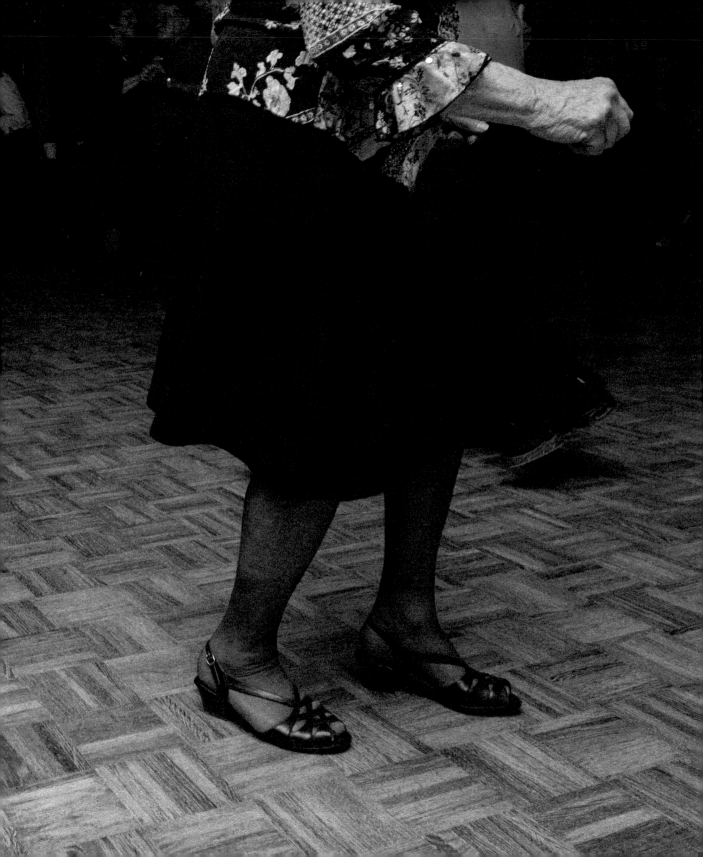

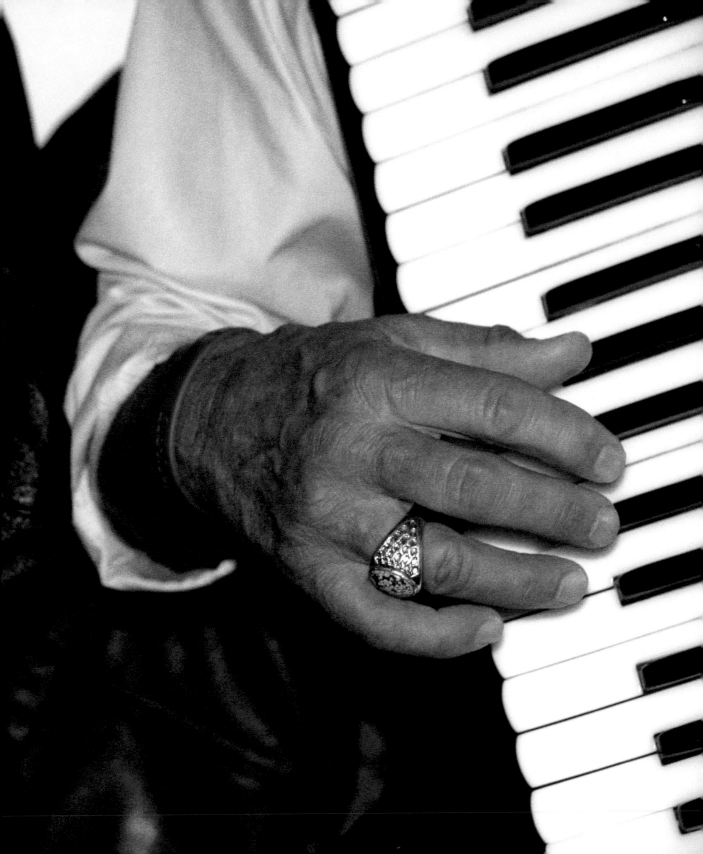

WHAT IS "SLOVENIAN"?

Cleveland and Milwaukee are known as two of the biggest polka-loving cities in the country. They are homes to the most active Slovenian-style polka scenes, and since Milwaukee is our home turf, Dick and I ventured out to several polka events where local bands played skillfully in Slovenian style. It's the music Frankie Yankovic made famous and the sound of polka that is by far the most familiar to the general American public.

The term *Slovenian,* however, is pretty obscure in common American discourse. Nonetheless, it seems to crop up in the polka world quite often. So just what does *Slovenian* mean?

Actually, Slovenia is a small country in south-central Europe that borders Italy, Austria, Hungary, and Croatia. It should not be confused with Slovakia, another country farther to the northeast where they are more inclined to play the czardas on violins than the polka on accordions. Slovenia's total population is scarcely more than two million people. It is ethnically homogeneous;

Jerry Halkoski at the Polish Center of Wisconsin in Franklin

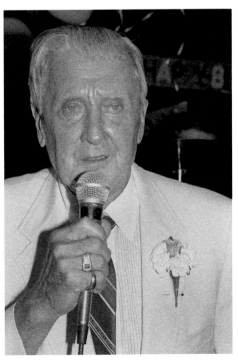

Frankie Yankovic performing in 1990 at Jolly's Inn near Milwaukee

Slovenian, a Slavic language, is spoken by the vast majority. The eastern, or Julian, Alps cover much of this mountainous country. Slovenians share many cultural qualities with other Alpine peoples such as Austrians, Swiss, and southern Germans, including a love of sausages and sauerkraut and musical traits like yodeling and squeezing button accordions.

Between 1880 and the outbreak of World War I, a significant number of Slovenians immigrated to the United States. They usually landed in Cleveland, Pittsburgh, Chicago, Milwaukee, or one of the mining towns in the Lake Superior region. No reliable statistics on the number of these immigrants exist; most were recorded as "Austrians" at Ellis Island because Slovenia was then part of Austria-Hungary. Somewhere between two hundred thousand and three hundred thousand Slovenian Americans live in the United States today, less than .08 percent of the US population.

Nevertheless, when it comes to polka, Slovenians have had a huge impact both in Europe and in the United States, far out of proportion to their small numbers. In Europe, Slovenian accordionist Slavko Avsenik became a huge star in traditional music. Slavko's five-piece ensemble (trumpet, clarinet, accordion, bass horn, and guitar) started in 1953 and was active for more than forty years. His band became the model for hundreds of Alpine-style ethnic musical groups, not only in Slovenia but also in Germany, Austria, Switzerland, and northern Italy. Slavko's ensemble was known by two distinct names: one in Slovenian, "Ansambel bratov Avsenik" (or, Avsenik Brothers Ensemble) and one in German, "Slavko Avsenik und seine Original Oberkrainer" (or, Slavko Avsenik and His Original Oberkrainers; Oberkrain is the historical German name for Slavko's home province, Gorenjska).

The group's characteristic sound was an immediate success beyond Slovenia as soon as their early recordings on the Jugoton record label were heard on Austrian radio in the 1950s. During the course of his career, Slavko composed more than one thousand songs. His ensemble typically included a trio of singers who sang both in Slovenian and German—"with a charming Slavic accent," as one German reviewer put it. They performed frequent concerts, appeared on television in West Germany, and landed a recording contract with Telefunken-Decca in 1960. In total, more than thirty million of Slavko's recordings have been sold. His group won numerous awards; eighteen times they were selected as Germany's most popular band.

Slavko wasn't only popular in Europe. He gained many American followers as well. His group toured the United States and Canada in 1970 and 1985, and several American bands have been influenced by his European style, notably Hank Haller, Duke Marsic, and Fred Ziwich in Ohio, and Roger Bright from Wisconsin.

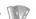

But the Slovenian musician who had the greatest impact in the United States has turned out to be the button accordion virtuoso Lojze Slak. Born in 1932 in a village in central Slovenia, Lojze learned to play the button accordion from his uncle while Lojze was still a small child. He began playing for dances at age fifteen but didn't gain widespread attention until ten years later, after he made an appearance on a radio talent show. Suddenly famous in Slovenia, Lojze formed a band with his three brothers. Later they joined forces with a vocal quartet, Fantje s Praprotna (The Boys from Praprotno).[41]

In the 1960s, the music of Lojze Slak was played frequently on Slovenian American ethnic radio programs. His music revived popular enthusiasm for the diatonic button accordion, which had faded in the United States thanks to the popularity of the newer Yankovic polka style. At the same time, button box clubs began to pop up in larger Slovenian American communities. The ensembles that played at these clubs included anywhere from four to more than twenty amateur button box players, backed by a small rhythm section.

The Badger Button Box Club performing at Jolly's Inn

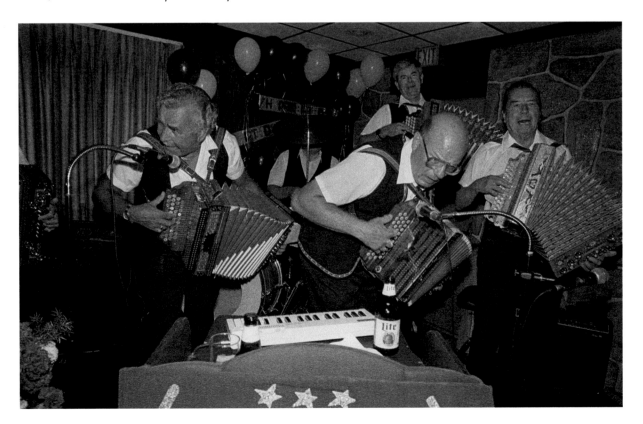

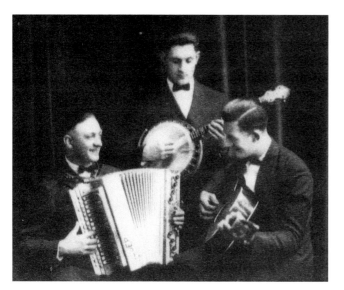

The Hoyer Trio, originally from Cleveland, Ohio, performing in the 1920s

The traditional button box and the modern piano accordion have been vying for popularity in the Slovenian polka scene for more than seventy years. Developed in central Europe in the mid-nineteenth century, Alpine button accordions usually are decorated with elaborate wood inlay. Most button accordions feature two or three rows of buttons on the right side, and it is most practicable for a player to produce only major key melodies in two or three keys. Button accordions have a unique sound. The reeds are tuned in a manner known as "wet tuning." Each button produces a note generated by two to four metal reeds. One of the reeds is tuned a shade higher and another a bit lower than the absolute pitch, producing a wavering and shimmering tone as they sound together. On the left side, about a dozen buttons produce chords and surprisingly loud, low, "helicon" bass notes, named after a type of tuba.

Slovenians adopted the button box in the nineteenth century, and the instrument was cherished by early immigrant communities in the United States. Matt Hoyer, a button box builder, repairman, and fabulous player who immigrated to Cleveland in 1911, formed the Hoyer Trio in the early 1920s. His was the first Slovenian polka band to have commercial success in the United States. The Trio toured in Hoyer's Model T Ford.

In 1919 Hoyer began an extensive recording career for the Victor, Columbia, and Okeh companies, and his records spread the Hoyer Trio's fame well beyond the Slovenian community. The straightforward, cheerful Slovenian melodies played in the familiar polka and waltz rhythms have proven to have great appeal to a wide audience that appreciates central European music. The Hoyer Trio remained active into the 1950s, but by then even Matt Hoyer, the button box missionary, had felt the modernizing influences of Frankie Yankovic, the next great proselytizer of Slovenian polka. Succumbing to the influence of the modernized polka style that was sweeping the country, Hoyer ultimately switched to the chromatic 120 bass accordion late in his career.

While Matt Hoyer may have had the first significant US music career playing Slovenian music, Frankie Yankovic's breakthrough into celebrity in the American music industry outshines any other American polka musician. In the United States,

A popular publicity photo of a younger Frankie Yankovic

Courtesy of Wendell Gibson

if you loved polka or hated it, you would have heard of Frankie Yankovic. The story of his young life is typical of early twentieth-century American Slavs.

Frankie's parents were immigrants to the United States. They both arrived about 1903. They met and married in 1910 while working in a lumber camp in Davis, West Virginia. Frankie's mother, Rose, cooked and baked for more than seventy Slovenian lumberjacks while Frankie's father, Andy, ran the camp and supplied workers with his homemade wine and liquor. In 1915, after being arrested on a bootlegging charge, Andy jumped bail and headed to Cleveland, the center of Slovenian America. Several weeks later, Rose gave birth to Frankie. With three daughters in tow and eight-day-old Frankie in her arms, she caught a train to join Andy in Cleveland.[42]

Young Frankie grew up in the Collingwood neighborhood on the east side of Cleveland. The area was home to Italians and Slovenians, and back then immigrants like Andy and Rose could get along there quite well in their native tongue without

knowing much English. Andy worked as a crane operator for a steel company and later started a hardware business, while Rose augmented the family income by taking in boarders.

Frankie Yankovic imbibed the musical influences of his boyhood home, the Slavic music made by his mother's boarders, and the jazz he heard on the radio. As a boy, he had to defy his tradition-minded father's insistence that he stick to the Alpine button accordion, which a boarder had taught him to play. With the help of his mother, Frankie obtained and mastered the modern and versatile piano keyboard accordion. After learning to play it in secret, he revealed the new instrument to his father on Christmas Eve, walking into the dining room while playing "Marička Pegla," Andy's favorite Slovenian folksong. The elder Yankovic withdrew his objections (what else could he do?), and Frankie went on to create a new hybrid Slovenian American polka music, borrowing the banjo and string bass rhythm section from American jazz and substituting English-language lyrics for the Slovenian words. His quartet had already achieved local renown in Cleveland by the time Frankie was swept up into World War II, serving as an infantryman in Europe during the war.[43]

Yankovic nearly lost both of his accordion-playing hands to frostbite when he was pinned down in freezing weather during the Battle of the Bulge. Refusing amputation, he managed to recover. In the army, he encountered another American musical influence—Southern country music. He heard "Just Because," a country song by the Sheldon Brothers, a Texas "hillbilly" group, and decided it would make a fine number to perform in his polka style. A couple of years later, it was the song that launched his successful music career.[44]

Through a fortuitous coincidence, he named his group Frankie Yankovic and the Yanks, owing to the first syllable of his last name. As the Yanks, the band exalted their American identity. Yankovic was a Yank! And he performed all over America. For decades, Frankie and his band would crisscross the North American continent, playing from coast to coast, but especially concentrating on the strongest hotbeds of polka enthusiasm, the midwestern states and Pennsylvania.

Thus it was that during my first full decade of life, I saw a lot of polka dancing and heard plenty of Frankie Yankovic's music, as well as the sounds of dozens of other polka musicians. If you would turn on the radio in the 1950s, you were likely to hear, "My wife she is drunk and I've got to take her home," "Beer Barrel Polka," or "Tavern in the Town." We even had a shirt-tail family connection to Frankie Yankovic himself. Much of my extended family joined the wave of midwesterners who relocated to Southern California during and shortly after World War II. We came from Chicago, but in California in 1954 my cousin Gloria met and married another midwestern

polka enthusiast, former Ohioan Matthew "Mike" Kurilich, a native of Collingwood, Yankovic's neighborhood in Cleveland. A few years younger than Frankie, Mike was acquainted with the soon-to-be-famous musician and was a close friend of Frankie's little brother Jerry.

About 1980, when Mike and Gloria were visiting me and my family in Milwaukee, we went to see Frankie Yankovic playing in a big tent on the parking lot at the nearby South Gate shopping mall. Mike approached Frankie on his break. Yankovic, who never lost touch with his community, recognized him right away.

"Hey, Kurilich, where have you been lately?" Frankie said.

"Well, I've been living in California for the last thirty years," Mike said.

"Oh, then that must be why I haven't seen you around," Frankie replied.

Yankovic's breakthrough into the pop charts in 1947 spawned a polka craze.

Louie Bashell performing at Jolly's Inn

A host of Slovenian polka bands formed, especially in Yankovic's hometown Cleveland, and the genre came to be called "Cleveland style." Some of the bands were led by Slovenians, such as Louie Bashell, Johnny Pecon, Lou Trebar, and Johnny Vadnal, but a multitude of these bands were formed by musicians of other nationalities.

Just as Slavko Avsenik was soon to do in Europe, Yankovic and his style of music transcended the boundaries of his ethnic community in the United States. A few examples of prominent Slovenian-style polka bands led by non-Slovenians include the likes of Kenny Bass (Croatian), Verne and Steve Meisner (Austrian), Joe Fedorchak (Ukrainian), Sam Pugliano (Italian), Roger Bright (Swiss), and Florian Chmielewski (Polish). With its jazzy banjo and English song lyrics, the Yankovic style became the most widely recognized, most commercially successful, and most "American" of the polka styles. Slovenians in Europe as well as Slovenian Americans are proud that music from their culture has received wide acclaim and that Slovenian musicians have put their small nation on the map.

Frankie Yankovic helped turn Milwaukee into one of the biggest Slovenian-style polka hotbeds. The

Album cover from
the Cleveland
Slovenian greats
Johnny Pecon and
Lou Trebar, 1970s
Personal collection
of Rick March

city is a close second to Cleveland, the style's hometown. Slovenian Americans constitute only a sliver of Milwaukee's population. Nonetheless, Milwaukeeans love the Slovenian sound.

Frankie Yankovic was warmly embraced in Milwaukee in the immediate post–World War II years. In 1948 at a "battle of the bands" event in the Milwaukee Civic Auditorium, Yankovic was crowned "America's Polka King" by acclamation of the crowd, a title he used ever after.

Despite being a "king," Frankie was truly a man of the people. Through his accessibility and warm, friendly nature, Yankovic gained devoted fans and inspired talented followers wherever he performed.

One such follower was Wisconsin's Verne Meisner, who became a polka great, one of the most acclaimed accordionists in the Yankovic style. As a young boy in Whitewater, Wisconsin, he learned to play from listening to Yankovic records and later from Frankie himself when, at age sixteen, Verne served a musical apprenticeship touring with Frankie's band. Verne had a successful music career, composed polka standards like "El Rio Drive," and made dozens of well-received recordings. He passed the polka fever on to his son Steve, who, in the late 1960s at the age of eight, made his first appearances with his dad's band. Steve had to stand on a box to reach the microphone. Like his father, Steve Meisner has enjoyed a decades-long career in his own right as one of the nation's premier players of Slovenian-style polka.

Another polka great who followed in Yankovic's footsteps was Grant Kozera, nowadays the leader of the Brewhaus Polka Kings. Grant was born in Milwaukee in 1958 into a polka-loving family, and like Verne Meisner, he was inspired by Frankie Yankovic at an early age. When he was just seven years old Grant made his first appearance on a stage at Milwaukee's Melody Bar where he "played" a toy guitar with the Yankovic band. It was the start of a lifelong friendship between Frankie and his young admirer; Grant was hooked on polka.

Shortly thereafter Grant began taking accordion lessons. He remembers a conversation in which Frankie told him, "Grant, one of these days you will have your own band and maybe I can play with your band."

The Polka King's prophesy proved accurate, but at first it was the other way around. Like Verne Meisner, a teenaged Grant served an apprenticeship in Frankie's band, and later as an adult he toured the country as Frankie's second accordionist. After Grant established his own band in the 1970s, Frankie often traveled to Milwaukee gigs alone, playing with Grant's band and backing him up. In the 1990s Frankie made his last recordings with the Grant Kozera band.

Frankie Yankovic died in 1998, but even in the twilight years of his career, he still proved able to inspire new followers, including Milwaukeean Mike Schneider, another prodigy on accordion, born in 1979. In 1997, at the age of eighteen, with sidemen many years older, Mike established a Slovenian-style polka band in the Yankovic model.

More than a half century since being crowned Polka King in Milwaukee, Frankie Yankovic's musical legacy remains strong in southeastern Wisconsin and in polka hotbeds across the nation.

Steve Meisner on accordion, with sideman Don Hunjadi on saxophone, at the Heat Wave Polka Fest in Kewaskum, Wisconsin

POLKA INTERLUDE

The Baldonis of Castelfidardo

The bellows of my button accordion had an air leak, and a couple of reeds weren't performing properly. It was time to have it repaired, and Baldoni's was the obvious choice. This was my chance to introduce Dick to an amazing place that is essential to our region's polka scene.

For the past half century, Milwaukee-area musicians have flocked to the Baldoni Accordion Company, a Wisconsin outpost of the famed Italian city of Castelfidardo, known for its accordion manufacturing. In the early 1960s, when he was a young man, Castelfidardo native Alfonso Baldoni and

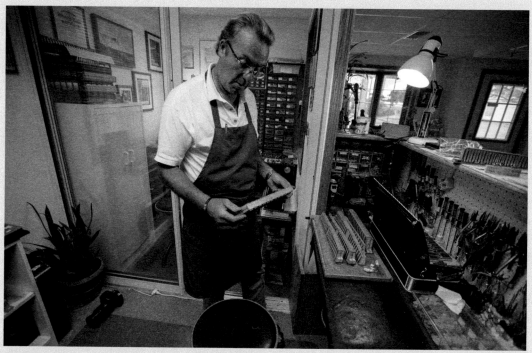

Ivo Baldoni in his workshop

POLKA INTERLUDE

A Baldoni chromatic accordion

his wife and children came to Milwaukee, where they soon established an accordion-making business on Brady Street, in the heart of the near-north side Italian neighborhood. For decades the Baldonis have supplied what loyal customers argue are the finest accordions a person can play.

Castelfidardo has been known for its accordion making since 1863, when the legendary artisan Paolo Soprani began to produce the instrument. Soprani family legend has it that an Austrian pilgrim on his way home from a visit to the nearby Loreto sanctuary asked to stay the night at the Sopranis' farmhouse. After enjoying a meal, the Austrian sat down by the fireside and began to play a strange "box." Paolo, still a young teenager, was fascinated by

this musical wonder, the type of *Akkordeon* patented in 1829 by Cyrill Demian of Vienna. In the night, while their guest slept, Paolo couldn't resist opening the music box to learn how it worked. He was hooked. A few years later, in 1863, he opened a small workshop that eventually grew into a still-active, world-famous accordion-manufacturing concern employing more than four hundred workers.

As the popularity of the accordion surged, several more instrument makers established factories in Castelfidardo. The highly skilled work of creating and assembling the six thousand parts that go into a full-size accordion became a local specialty. The skills have been passed on in a traditional manner in the Castelfidardo artisan families. The industry's peak there came in 1953 when more than three dozen manufacturers employed nearly ten thousand workers and produced more than two hundred thousand accordions.

Today, most accordions are manufactured in Asia. But in Castelfidardo, twenty-seven makers remain, supplying high-end instruments to the market. The nicest models sell for as much as thirty thousand euros, or more than forty

POLKA INTERLUDE

thousand dollars, and purchasers from all over the world make the pilgrimage to Castelfidardo to obtain them.

As a polka town and an accordion hotbed, Milwaukee was a fertile location for Alfonso Baldoni to establish his business. Polka players needed good accordions, and Alfonso developed an accordion model called the American Polka, which soon became a favorite among popular musicians.

Baldoni's is a family business. Alfonso's son Ivo learned the trade; and since Alfonso's passing in 2006, Ivo and his wife,

Peggy, have continued to run the company. Ivo, Peggy, and their employees repair and recondition instruments. Family members back in Italy manufacture new Baldoni accordions precisely to the American customers' specifications. Each day, Ivo uses Skype to confer with his uncle and brother-in-law in Castelfidardo about business operations.

Several years ago the Baldoni shop relocated to the Milwaukee suburb of Menominee Falls. The shop is a palpable shrine to the accordion. The showroom walls are lined with sparkling new and vintage instruments. A map of Castelfidardo hangs on one wall, and satellite radio plays music and news in Italian.

Dick and I stopped by the shop one afternoon in summer 2013. Ivo took my accordion and popped the pins holding the bellows in place. With a trained eye he peered inside, diagnosing the service needs of my Slovenian-made button box. He

Peggy Baldoni

POLKA INTERLUDE

was quick to point out an inferior shortcut repair a friend had performed a few years earlier. "I know," I said, "but now let's have you do it right."

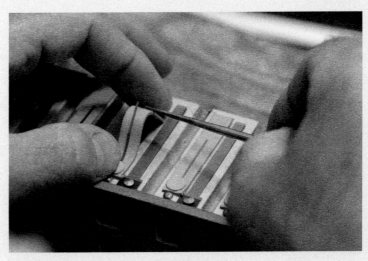

Ivo Baldoni skillfully repairs an accordion reed.

Despite being swamped with work to finish before their family's upcoming vacation in Castelfidardo, Ivo and Peggy invited us to hang around as they worked. After closing the store, they continued to work well into the evening, painstakingly securing reeds with a traditional adhesive composed of beeswax, linseed oil, and a third ingredient, which remains a family secret. After heating and mixing the adhesive for Peggy to apply, Ivo entered the reed-tuning booth for a while, where he carefully filed away minute amounts of metal until the reeds were in perfect tune. It was a tender and quiet end to the workday for a couple who had long shared their life and work, whose skilled efforts made sweet music possible.

MEXICAN POLKA

I f you are looking for the Vegas Latin Night Club in Oregon, Wisconsin, it helps to know exactly where you're going. Dick and I drove past the place twice, down a dark road through a warehouse district on the north edge of town. We finally decided, according to the GPS on Dick's phone, that a large warehouse with a sign reading Capitol Storage had to be the place. But I'll have more about that in a bit.

We were looking for a Mexican polka dance. The polka has remained more central to the music of Mexico and the Mexican diaspora in the United States than in any other musical culture. Since its introduction into Mexico from Europe in the mid-nineteenth century, the popularity of the dance and its musical accompaniment has never faded. Nowadays in the United States, songs in the polka rhythm are million-record sellers on the Latin Billboard charts. Videos on YouTube of the popular *exitos* (hits) get multiple millions of views. For example, the song "Que Me Lleve el Diablo" by the Norteño-style group Los Huracanes del Norte had received almost six million views as of October 2014. The polka and waltz tempos are so ingrained in the music that Mexican bands don't call themselves polka bands. Similar to the way the Dutchman and Bohemian bands eschewed the term *polka band,* the Mexican bands classify themselves as *Norteño, conjunto,* or *banda,* and polka is but one important dance rhythm in their repertoires.

Regrettably, there are still considerable social barriers between Spanish-speaking immigrants and the rest of American society. Although I've long known about Mexican polka and have enjoyed listening to my recordings of the music, I have had no easy entry point into the Mexican music scene. But Dick and I were determined to represent this notable, perhaps foremost, setting for polka music in current American culture. We had formidable language and cultural obstacles to surmount. My Spanish

The Vegas Latin Night Club in Oregon, Wisconsin

Flaco Jimenez, a
Grammy-winning,
Norteño-style
musician from Texas
who later played
with Bob Dylan,
Ry Cooder, and the
Rolling Stones, in a
promotional photo
taken in the 1980s

Photo by Chris
Strachwitz, courtesy
of Arhoolie Records

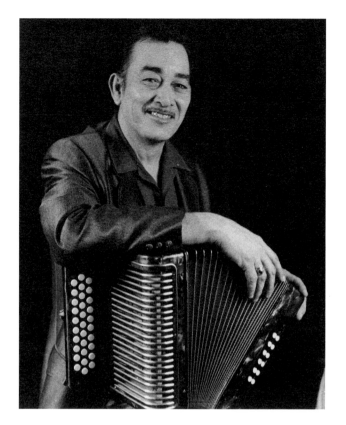

is weak for anything beyond the simplest of conversations. Moreover, we wanted to be respectful of the fact that some immigrants who were undocumented might fear being photographed by us. Nonetheless, we were resolute.

Our search for a Mexican polka dance in my area began in the Marimar Mercado, a Latino grocery store in Madison. There I spotted a poster announcing a Friday night dance at the Vegas Latin Night Club in nearby Oregon, Wisconsin. The Mazizo All-Starz were the featured band. They were pictured on the poster, six well-groomed young men in shiny black suits and ties. The deep purple of their dress shirts matched the color of their logo, a purple star emblazoned with a scorpion, the symbol of Durango, their homeland. The whole image was superimposed on a blazing fiery background. The scorpion logo was a sure sign they played *banda duranguense,* or Durango band music, which has been wildly popular for the past decade among Mexican Americans.

Banda duranguense, however, did not originate in Durango, Mexico, but rather in Chicago, Illinois, where a large number of immigrants from Durango settled. Durango

is a railroading center in Mexico; early in the twentieth century, railroad workers from the region were lured to jobs in the Midwest, especially the Chicago area, by North American railroad companies.

From the start, music and polka dancing were a part of life in the community, jokingly referred to as Durango, Illinois. In the late 1970s the modern *duranguense* style of music began to emerge in Chicago. At that time, synthesizers had appeared as an important instrument in North American pop music. It was natural that Mexican Americans (who called the synthesizers *teclados*) would experiment with these new musical gadgets as a way to modernize their *banda* music, which previously employed traditional brass, reed, and percussion instruments.

It proved easier to set a synthesizer's tone to imitate a tuba than to carry the big brass horn to gigs. The electronic tone invoked modernity, reflective of the Durangans' new way of life in Illinois. On a synthesizer, the same player could provide a tuba-like bass line with the left hand and rhythmic off-beats with the right. A second *tecladista* (synthesizer player) could provide melody and harmony parts to imitate the tone of trumpets or clarinets.

A small band might consist only of a pair of *teclados* plus a drummer. Bigger ensembles typically add a saxophone player and a trombonist. *Duranguense* style calls for the heavy percussion common in Mexican regional music known as *tamburazo*. Originally a *tamburazo* drummer used only a small bass drum with a cymbal mounted on its top. Using a handheld second cymbal, he banged out clashes, while pounding an active rhythm with the other hand using a large, padded drumstick. Nowadays, active drumming on a modern drum kit is more common, but many *duranguense* bands include two percussionists, on both drum kit and *tamburazo*. Typical *duranguense* dance rhythms include polka and waltz, as well as tropical tempos like cumbia and merengue.

While a few leading groups claim to have originated the *duranguense* sound, such as Grupo Montez de Durango and Los Creadorez del Pasito Duranguense, an even earlier *duranguense* pioneer musician was Armando Terrazas.

Armando became a widower in 1985, when his two daughters, Marisol and Vicky, were nine and six years old. Not wanting to entrust them to anyone else's care, Armando took the girls to his gigs, and they soon became part of the act, Marisol as a *tecladista* and Vicky as a singer.[45] The daughters have subsequently become big stars. Their band, Los Horoscopos de Durango, is nationally and internationally famed as one of the leading *banda duranguense* acts.

Back in Oregon, Wisconsin, Dick and I arrived at the Vegas Latin Night Club on the night the Mazizo All-Starz were scheduled to play. The All-Starz are a *duranguense*

band formed in Chicago in 2003 by three brothers, Ricardo, Raul, and Diego Obregon. The band has had a successful, ten-year career with several hit songs on the Latin charts. On the dark, nearly empty parking lot, just as Dick and I were beginning to fear we were on a wild-goose chase, the Mazizo All-Starz pulled into the lot in a van with Illinois plates.

Dick and I approached the young men, who were starting to unload their band equipment. Band member Ricardo Obregon assured us this was indeed the location of the Vegas Latin Night Club. I recognized Ricardo's south side Chicago accent right away. Ricardo used a cell phone to contact someone inside the massive warehouse; a few minutes later, a young man appeared to push open the locked glass doors.

We entered an expansive, high-ceilinged interior that was outfitted as an indoor soccer facility. Interlocking foam rubber tiles softened the expanse of floor. There were netted soccer goals and a Plexiglas-protected altar to the Virgin of Guadalupe mounted high on one wall. After a long stroll past soccer fields, we came to a partition where the foam rubber tiles came to an end, giving way to a smooth, concrete floor. Against one wall was a small stage with a proscenium decorated with images of playing cards and the words "Vegas Latin Night Club" in big block letters. Opposite the stage, separated by a mostly Plexiglas wall, was a nicely outfitted bar. An elevated soundman's booth was likewise surrounded by Plexiglas.

Dick and I met with the two owners of the soccer/music club business, a Puerto Rican and a recent Mexican immigrant. We had a pleasant conversation and convinced them we were not with La Migra, the ATF, the FBI, or any such authority. They treated us to beers and said we were welcome to photograph the goings-on.

Ricardo Obregon was nervous. He feared nobody was going to show up. He had just learned there had been a big, free show there the night before, sponsored by a telecom company as a promotional event, featuring Los Horoscopos de Durango. Vicky and Marisol Terrazas were bigger stars than ever since their November 2012 arrests in Okeechobee, Florida, while playing for a rodeo there. A disturbance broke out and the local police providing security started to aggressively rough up the crowd. Marisol castigated them.

"Hey, stop beating Mexicans," she shouted.

Police officers came onto the stage to arrest the sisters, but Vicky and Marisol, tough Chicago girls, fought them off in full view of the audience. They escaped to their bus, where eventually they were arrested. The police charged them with felony counts of inciting a riot and assaulting an officer. The incident was widely reported in the Spanish-language media, and their case became a cause célèbre in the Mexican American community.[46]

Only a few weeks before the Terrazas sisters' show at the Vegas Latin Night Club, their lawyer arranged a plea bargain. The sisters pleaded guilty to lesser charges and received community service sentences. In their televised public statements on Univision and Telemundo, the singers seemed repentant, but to the community they were heroes. Marisol and Vicky have become something like modern-day female iterations of the famed Gregorio Cortez, a hero in Mexican American culture who, in 1901, fought off Texas Rangers, was captured, tried, jailed, then ultimately exonerated and pardoned. The owners of the Vegas Latin Night Club told us there had been a huge turnout the night before to see the sisters play.

With such a big crowd the night earlier, Ricardo feared no one would turn out to see his band. But around 10:30 p.m., a small but decent-sized crowd began to arrive for dancing. They were mostly young people who arrived as couples. Most of the women had elaborate hairdos and wore stylishly short dresses. The men sported dress shirts and slacks, and about a third of them wore cowboy hats and pointed boots.

As the dancers began to arrive, the harsh environment of the warehouse building became transformed into an ethereal space by an elaborate light show. A rotating disco ball hanging from the middle of the ceiling reflected the light, and laser lights from the stage dramatically shot bright green beams across the room.

This crowd had come to dance, and dance they did. Only a minority spent any time in the bar, and those who did found tables near the dance floor. Most of them seemed to nurse a single beer or bottle of water all evening. One family had a four- or five-year-old boy in tow who dashed around the floor wearing a cowboy hat. There were a couple of girlfriend pairs who danced together, but young male-and-female couples predominated, dancing almost exclusively with their own dates.

The music was loud. You could practically feel the vibrations hit your face. To dance here was an all-engrossing experience. I thought about these predominantly youthful Mexican Americans, many of whom might be immigrants. They were replicating, a century later, the way European immigrants had used polka to form community. No matter who or where you are, dancing while tenderly holding your spouse or sweetheart is a good thing in life.

The loud music and the language barrier made it hard to communicate much, but the people offered us kind glances, unperturbed by Dick moving among them to photograph. It made me think with regret about how segregated our society is. There are very few Mexicans who attend Euro-American polka dances, and absolutely no other non-Latinos found their way to this practically "underground" night club. I hope for a future when these barriers dissolve.

Vegas Latin Night Club

Opposite and pages 162–163
Couples at the Vegas Latin Night Club in
Oregon, Wisconsin, often danced closely
together during the polkas and waltzes,
separating during the cumbias and
rock-style songs.

Pages 164–165
Trombonist Jonathan Villagren and singer
Raul Obregon of the Mazizo All-Starz

Pages 166–169
Dancers at the Vegas Latin Night Club

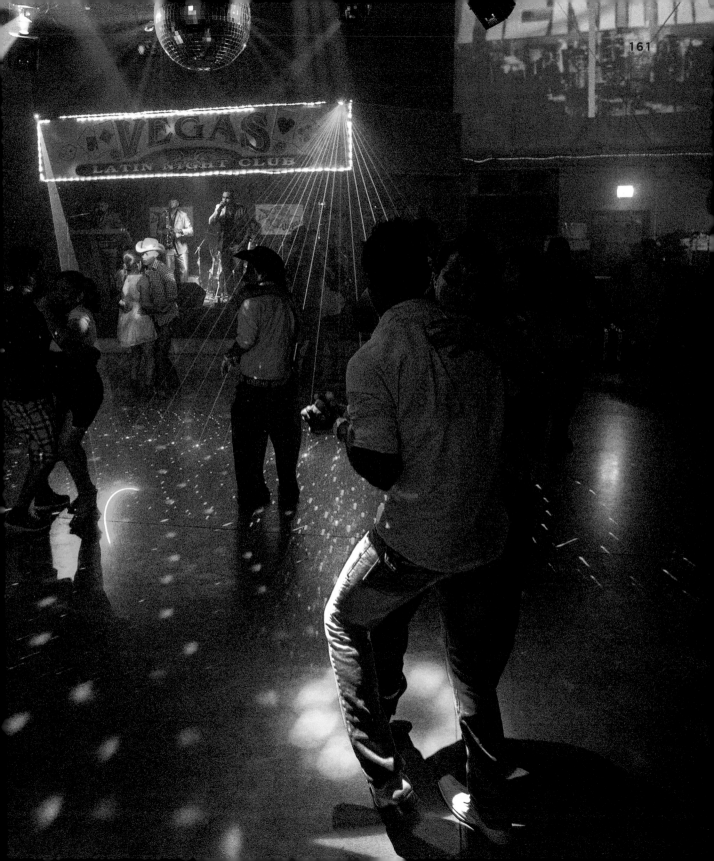

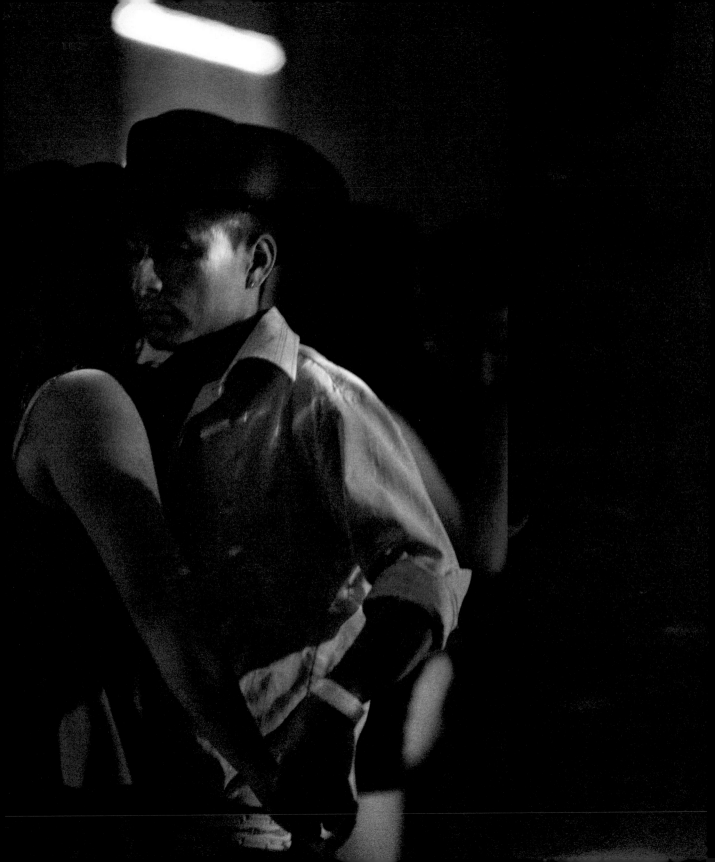

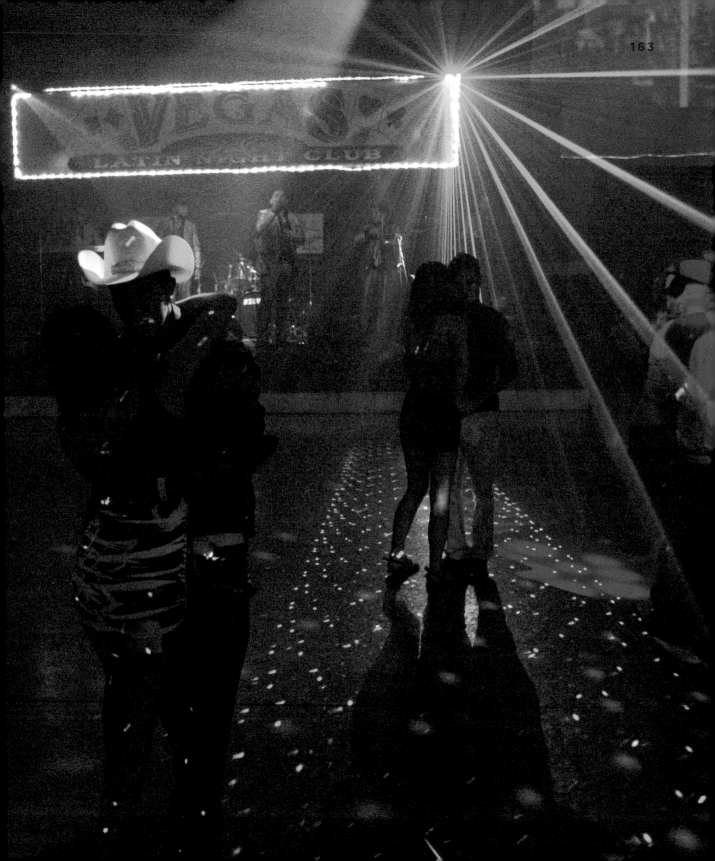

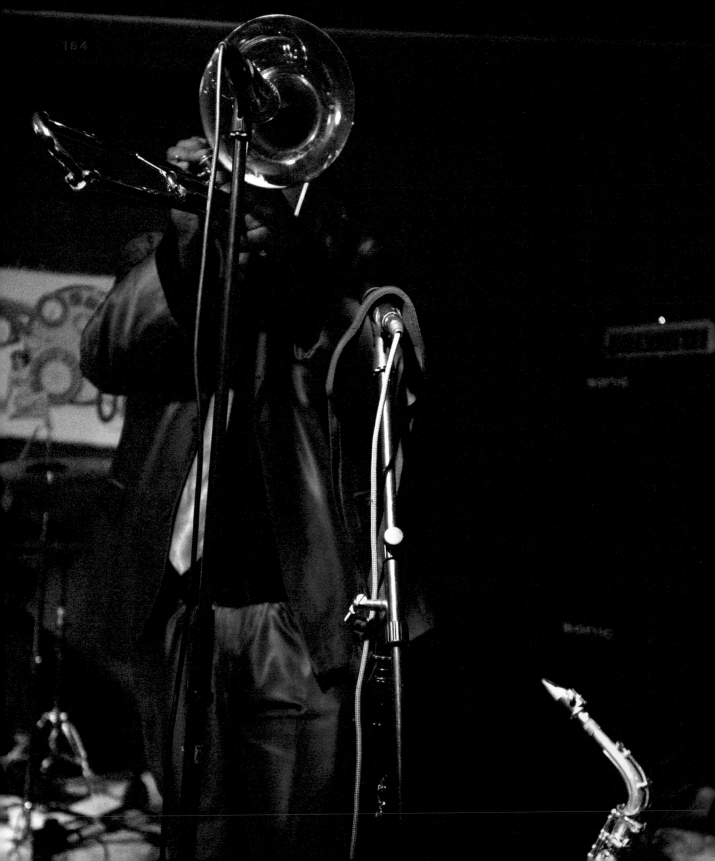

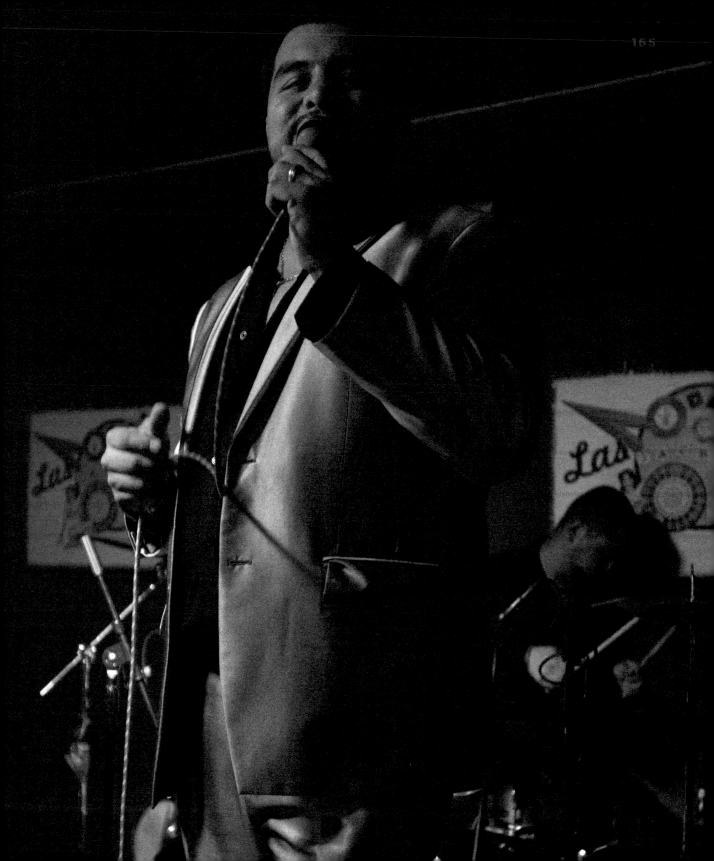

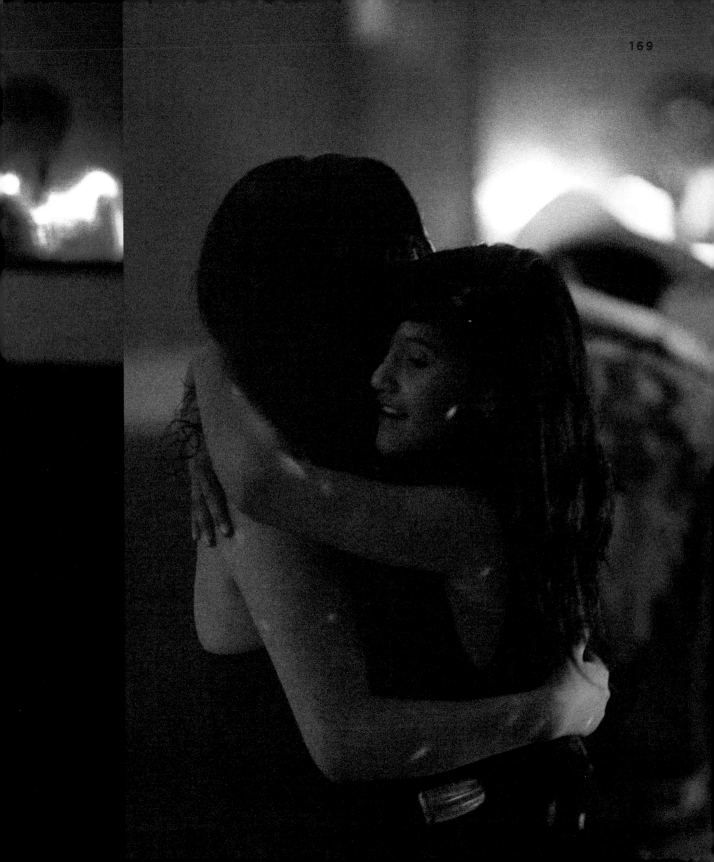

The Concertina Bar

The Concertina Bar is a classic corner tavern, a two-story brick building in the middle of an industrial neighborhood on Milwaukee's southwest side. When Art Altenburg bought the place decades ago, he figured it was a good business location, across the street from the Ryerson steel plant whose workers would stop in for a sandwich and a beer. And it was a place for Art to showcase his true passion, his extensive collection of Chemnitzer concertinas.

Instead of bottles of liquor, about forty squeezeboxes were crowded onto the shelves behind the bar. Without much convincing, Art could be persuaded to take one of them down. He didn't need to strap

Kochanski's Concertina Bar

POLKA INTERLUDE

on the concertina; instead, he would set the instrument on the smooth top of the bar and play it right there, the bellows snaking over the shiny lacquered wood.

Art came to Milwaukee from his hometown, Mosinee, a paper mill city in a famously concertina-loving area of central Wisconsin. Scores of the Portage County Poles and Marathon County Germans have made that area a Chemnitzer hotbed. Art carried the concertina players' chip on the shoulder about accordions, and he wouldn't allow the better-known type of squeezebox into his establishment.

"What about my button box?" I asked him once.

"It's still an accordion," Art insisted.

So when I played music in the Concertina Bar, it was on my tenor banjo, providing rhythm for players of the particular type of squeezebox to which Art was devoted.

From the 1970s until about 2010, musicians jammed there every Thursday, and professional bands played there every weekend. Art drew musicians mostly from the active Milwaukee-area scene, from his old home territory in central Wisconsin, and from Green Bay. Occasionally, western

Wisconsin squeezers like Karl Hartwich performed there, and I played banjo now and then for Len Stroszinski who, like Art, was a Mosinee native and a fine concertinist who ran the University of Wisconsin's dairy farm near Sauk City.

It's not a big place. But when the joint was jumping, twenty or so dancing couples could fill the floor, and a couple dozen more beer drinkers could stand along the bar to admire their moves.

Art ran the Concertina Bar for more than forty years. In the late 1980s the steel mill closed, so Art had to rely even more on music and dancing to bring in his customers. When he decided a few years ago to move back to Mosinee to care for his elderly mother, Art packed up his concertinas and sold the bar to Andy Kochanski, a young Milwaukeean who promised to continue the polka tradition. Andy, however, widened the musical offerings. He eliminated the ban on accordions so that pretty much any polka band was eligible to appear. He also added a few other kinds of music: rockabilly, surf rock, bluegrass, and blues.

Andy is proud of his Polish heritage; a Polish flag decorates the bar now, and

POLKA INTERLUDE

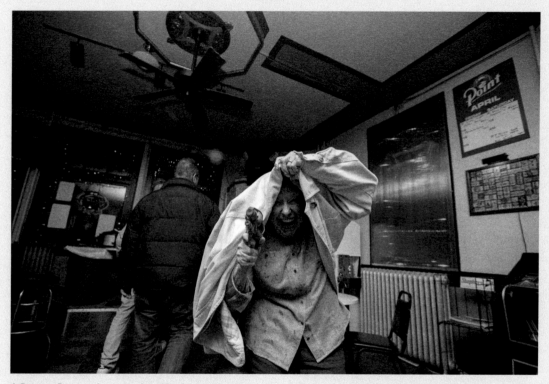

A Dyngus Day reveler at Kochanski's Concertina Bar squirts a water gun, per the Dyngus Day tradition.

Andy proudly claims he has the largest selection of Polish beers in Wisconsin. The Concertina Bar also is one of the few venues in the region to continue the old Polish custom of Dyngus Day, nowadays celebrated in its American iteration. Dyngus Day occurs on Easter Monday. According to tradition, Prince Miezko was baptized on that day in the year 966, bringing Poland into the sphere of Christianity. The custom, however, surely originated in pre-Christian pagan practices.

According to tradition, young men in Polish villages would whack young women with pussy willow shoots and splash water on them, a characteristic pagan rite of purification and fertility. In some places, it is reported, the women

POLKA INTERLUDE

had their revenge, returning the favor to the boys on Tuesday.

In the United States the custom continued in many Polish American communities, including South Bend, Indiana, and Buffalo, New York, which celebrates Dyngus Day with a parade, as well as parties in taverns, church halls, and ethnic lodges. The means of splashing water has morphed in the States into a water-gun fight, and women and men are equally likely to squirt their fellow revelers.

At the Concertina Bar, a small but lively crowd turns out every Easter Monday to enact the ancient ritual. They dance to polkas by musicians such as Tom Brusky, enjoy some beer, and engage in intermittent, carefree, squirt-gun fights.

Of all the little corner bars in Milwaukee and other midwestern industrial cities that once featured the polka, the Concertina Bar is one of the rare survivors. The torch has been passed to a new generation, from Art Altenburg's World War II generation to Andy Kochanski's millennials. The place is frequented by old-timers and trendy young folks alike. And polka, squeezeboxes, and Polish American customs remain central to the establishment's identity.

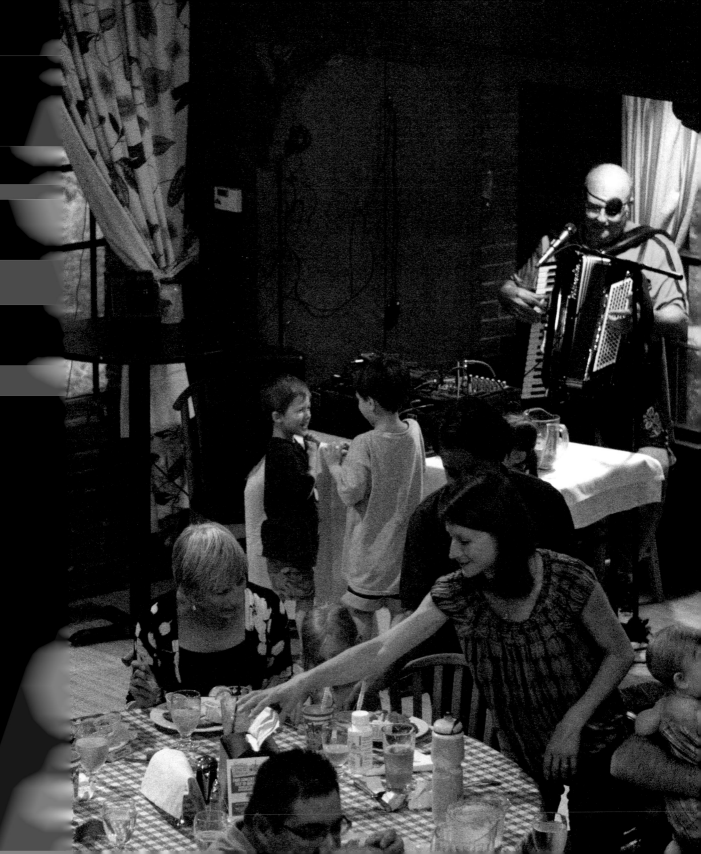

10

NEW DIRECTIONS IN POLKA

On a summer Friday evening, Dick and I went fish-fry hopping in Milwaukee. The Friday night fish fry is practically a holy institution in Wisconsin. After Prohibition was repealed in 1933, tavern owners sought to attract crowds back to their establishments by offering hearty, inexpensive dinners, typically beer-battered fish, cole slaw, and fried potatoes. Of course you'd wash it down with a beer or two.

In a state with many Catholics, Friday fish fries also built upon the Catholic custom of abstinence. Until the 1960s, Catholics were expected to abstain from eating meat on Fridays, as a form of penance in honor of the death of Jesus on Good Friday. Even after the Second Vatican Council liberalized Church doctrine by the mid-1960s, the fish fry remained an important culinary custom for Wisconsinites and other midwesterners of all religious backgrounds.

Polka is the distinctive music for a Milwaukee fish fry, and despite the fact that today only a few diners are likely to be skilled polka dancers, the music remains an expected part of the experience for many.

At the Lakefront Brewery Palm Garden in Milwaukee, Dick and I chatted with accordionist Grant Kozera, the leader of the Brewhaus Polka Kings. Grant's polka band has played this venue on Fridays for the last few years in front of a varied but generally younger crowd.

The pub is in a spacious former factory building with a high-ceilinged interior of exposed brick walls. The name Palm Garden is Lakefront's reference to the Schlitz Palm Gardens, the famed beer gardens of Milwaukee's past. Potted palm trees mounted high on brackets decorate the walls. When we visited, dozens of patrons drinking Lakefront's signature craft beers were gathered by the lengthy bar running

Accordionist Jeff Winard entertains diners at the Friday fish fry at Hubbard Park Lodge in Milwaukee.

Grant Kozera playing at Milwaukee's Lakefront Brewery in 2013. In front of him sits Frankie Yankovic's original Solovox, a kind of electronic keyboard.

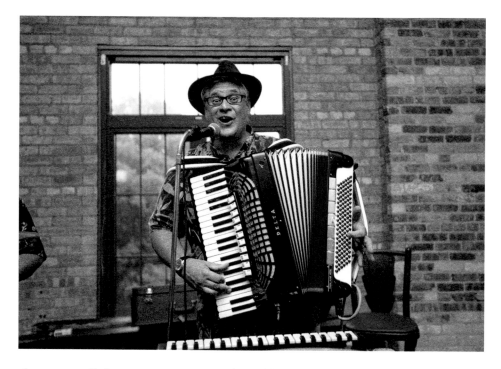

along one wall. Scores more were seated at tables, as waitresses holding big trays aloft brought them platters of steaming fish.

From the stage, Grant and his partner played Yankovic-style polkas. Nearby sat Lawrence Welk's original bubble machine, which Grant had purchased on eBay; it still worked, and a group of children chased soap bubbles while the grown-ups danced. But this really wasn't polka dancing. The couples didn't circle the floor, and many danced separately from their partners, making improvised motions just as they would do to rock music.

As a young man Grant had been a close friend of Yankovic, his elder and mentor, even making some 1990s recordings with the Polka King. At the Lakefront Brewery, Grant was using Yankovic's own Solovox, an early type of compact electric organ that Frankie had adopted in the 1940s to modernize his sound.

But the crowd at the Lakefront wasn't a typical polka crowd. I asked Grant how he liked playing this type of gig, with a general absence of polka dancers.

"Well, this is the new type of audience that we can reach," Grant said. He expressed some regret that able dancers were few that particular night, but he noted with approval that the elderly members of the Wisconsin Polka Boosters club show up to dance here from time to time.

Polka's economic engine long has been its audience—particularly the avid dancers who would pay admission to dance events and purchase beverages or food at taverns and halls where polka music was provided. A band's popularity depended on how well its rhythm inspired dancers into motion.

In the United States, during polka's earliest phase as a mid-nineteenth-century dance fad, the potential audience may have seemed unlimited. After its popularity faded, polka still enjoyed a big audience. America was awash with millions of immigrants and ethnic groups who considered polka a music and dance activity symbolic of their ethnic or regional identity.

In the earlier part of the twentieth century, polka benefited from the increasing popularity of social dancing as a form of leisure activity, but the prevalence of such dancing as recreation has steadily declined for decades. The audience in many polka scenes seems to be contracting rapidly, losing to old age most of the people who participated in the mid-twentieth-century polka craze, when the music had its last

A crowd dances to the Brewhaus Polka Kings during a Friday night fish fry at Milwaukee's Lakefront Brewery.

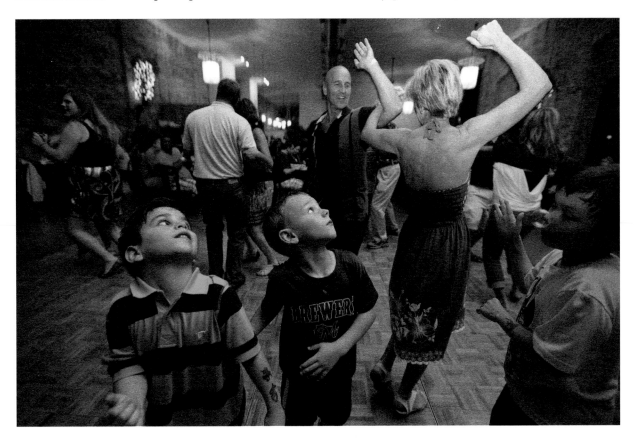

substantial success with mass audiences. Recent upticks of interest in ballroom, swing, and Latin dancing have largely bypassed polka. Indeed, polka has been dropped from the dance categories in the emerging sport of competitive ballroom dance.

The difficulty of attracting young followers is understandable. Today, more diversions and duties compete for a person's time. Moreover, for more than three decades polka has been disparaged in the popular media as outdated and uncool. Playing its characteristic instrument, the accordion, has been labeled the ultimate sign of geekiness.

Ironically, however, this disparagement has piqued a small but noticeable resurgence of polka in recent years, if not by the masses, then at least by some younger people who have embraced other indie and retro trends, such as fashions from the 1950s.

A good example of this is Donald Hedeker, a professor of biostatistics at the University of Illinois at Chicago's School of Public Health. When Hedeker slips on a frilly dress shirt with a gaudy vest or dons lederhosen and a plumed jaeger's hat, and then straps on his Gibson Les Paul, he assumes his alter ego of a maniacal rocker who plays polkas in his punk rock band, the Polkaholics.

The name of Hedeker's band is ironic because Hedeker's scholarly research concerns treatment of addictions. His music doesn't sound much like polka, and virtually none of his audience consists of traditional polka dancers. He plays for rock fans. The band's instrumentation, the musicians' playing technique, and their sound are fully within the punk rock genre, but the songs themselves, the Polkaholics' repertoire, includes a lot of tunes like "Beer Barrel Polka" that were the well-known polka hits in the 1950s.

Don is playing with complex sociocultural notions. The persona he projects in his Polkaholic act is a double irony, as he parodies the stereotype of the goofy polka musician that originated outside of the polka culture. Don is mocking the mockers. He juxtaposes incompatible elements—polka with punk rock, polka's sincerity projected into punk's typically cynical worldview. This creates a significant statement about what polka is and what punk rock is, and their differences as responses to the dominant forms of popular culture.

From the 1890s through the 1970s, Milwaukee's West of the River neighborhood

Don Hedeker and Jumpin' George Kraynak of the Polkaholics playing at the Cactus Club in Milwaukee

was a predominantly Polish American working-class area. Though a few elderly Poles still live here, the area has evolved to become the heart of the artistic "bohemian" section of the city. In 2006, the neighborhood gave rise to an ensemble that plays the most Bohemian of music, polka.

Artist Pam Scesniak and musician Linda Mueller have taken polka in a different direction. The two women recently decided to learn to play accordions. They recruited a rhythm section of drums and sousaphone, as well as jazz singer Chanel le Meaux, and formed the Squeezettes. They are prone to wear "retro" fashions, but their performance is not ironic like the Polkaholics. They have a lot of fun playing their eclectic repertoire, which includes several well-known polkas, as well as plenty of the music of their lives: old pop, rock, and country songs.

That the Squeezettes play their melodic lead on accordions is enough to lend a "polka" sense to their music, as far as their audience is concerned. Pam and Linda acknowledge they are far from virtuoso accordionists. They sound like, and actually are like, a little neighborhood aggregation, a pickup band that coalesced to play for someone's backyard party. Their eclectic repertoire and their lighthearted, enthusiastic performances have attracted bookings to play for non-polka, beer-appreciating audiences similar to that at the Lakefront Brewery, as well as occasions closer to the heart of the polka culture, such as Catholic parish festivals and the Cheese Days Festival in the Swiss American town of Monroe, Wisconsin.

While the Polkaholics and Squeezettes involve musicians from outside the polka world embracing the music in one form or another, the other side of the coin is represented by Copper Box, a band centered around a pair of exceptionally skilled musicians, the couple Danny and Michelle Jerabek. Danny and Michelle both grew up playing in family polka bands. They are deeply grounded in the polka tradition and occasionally still play in their families' bands. Thanks to their ability to play a variety of musical styles, they have fashioned polka-infused versions of jazz, Cajun, zydeco, bluegrass, *conjunto*, blues, and country songs.

Danny and Michelle are both scions of distinguished musical families: Danny is the son of the legendary Tuba Dan, the longtime bass horn player for the renowned Dick Rodgers Orchestra and an inveterate on-stage jokester. Viewers all over Wisconsin could see Tuba Dan performing with the Rodgers orchestra on the *Dairyland Jubilee* TV program in the 1970s, perhaps sporting gag google-eye glasses while he skillfully provided a solid bass line. Later he formed the Tuba Dan Band, with his wife, Lila, anchoring the rhythm section on drums and sons Danny and David serving their musical apprenticeships on a variety of instruments. Over time, Danny developed into a virtuoso player of the button accordion.

Michelle Thull Jerabek and Danny Jerabek Jr., from the Oshkosh-based Copper Box band, perform at the 2013 Wurst Fest in Johnsonville, Wisconsin.

Michelle's grandfather, Bill Thull, not only ran a dairy farm but was a noted saxophone player and leader of the Bill Thull Orchestra. His band was such a community institution that in the 1960s, a photo of him playing his tuba was featured in a *National Geographic* article about Wisconsin. Bill's accordion-playing son Ralph raised a brood of musicians, too, forming the Goodtime Dutchmen with his kids, including Michelle, who became a multi-instrument threat on three sizes of saxophone, trumpet, and guitar.

Playing with their respective family bands, it was inevitable that Danny and Michelle would cross paths at Wisconsin polka dances and festivals. Their romance blossomed and they married, uniting two polka dynasties. The young couple settled in Oshkosh, but initially they were expected to tour with their respective family bands on weekends: Michelle with the Goodtime Dutchmen and Danny in the Tuba Dan Band. Unfortunately, the two groups seldom played the same events.

Their bands would travel across Wisconsin, Minnesota, and Iowa, often figuring out on the fly where they would spend Friday and Saturday nights. Reunited on a certain Sunday evening, Michelle asked Danny where his bunch had spent their night. He named a certain town in Minnesota. "Wait," Michelle said, "we stayed there, too!" Further clarification revealed the husband and wife had stayed the night before in adjacent motels at the same freeway exit in Minnesota, unaware of the other's proximity.

"Well, that was it," they told me. "We decided then and there to give notice to our parents that we were leaving their family bands and we would form our own band together."

They did so, unleashing their musical creativity in new directions, combining musical ideas from the many other genres they enjoy into their polka-fusion ensemble, Copper Box.

They are booked at many community events in polka country where the elders tend to be polka devotees but the younger generation is looking for something different. Copper Box ably bridges the gap. They play and sing with the emotional intensity of rock musicians, fusing various musical styles into a jazzy mix. They are fun to watch as a show band, but their long polka experience has taught them how to make their music appeal to dancers, too.

Tom Brusky playing at Kochanski's Concertina Bar in Milwaukee

Milwaukee's Tom Brusky and Mike Schneider are two more younger musicians who have figured out how to make a living in the polka field. Like so many other polka musicians, Tom was born into a very musical family, learning at an early age to play piano, drums, bass, tuba, and his showpiece instrument, the accordion. He runs a highly organized music business that includes his Slovenian-style polka band and his full-service recording and CD production studio, Polkasound Productions. Tom supplements his work by administering websites for a number of polka musicians and organizations. His band plays about 175 events each year, mostly private parties. In addition, Tom frequently works as a sideman in the polka bands of his musician friends.

With fewer polka dance gigs available nowadays, Mike Schneider has found a new audience quite different from the tavern revelers that Tom Brusky typically plays for. As a teenage bandleader in the late 1990s, Mike made a splash on the Milwaukee polka scene. Now in his mid-30s and the father of young children, Mike is an educated person with an impulse to teach. He has created Pint Sized Polkas, programs for children. "Uncle Mike" tours widely, presenting his interactive programs as a solo accordionist in schools and public libraries. In the summer of 2013 he barnstormed through ten states, including areas as far from "polka country" as Virginia and Georgia. While he is teaching about polka, he cleverly uses the music and dance to advance other basic curriculum goals. His programs have received rave reviews from educators and librarians.

Another newer development in the polka world can be seen as enthusiasts from differing styles of polka music coalesce around the stronger events and organizations. Until recently, devotees of one polka style usually avoided the music of other styles. But with a declining overall audience, the polka scene can no longer afford such divisiveness. Nowadays, to appeal to a wider audience, most polka festivals include bands that play differing styles, as well as a few bands like the Thull family's Goodtime Dutchmen and Molly Busta's Squeezebox Band that are capable of creditable renditions of polkas in three or four styles.

The healthiest component of the Euro-American polka scene seems to be Polish. Nationally, there are more active bands and events that emphasize Polish-style polka than any other nationality. And they attract a greater number of younger people. Polish Americans across multiple generations have strongly retained their ethnic identity. A considerable percentage of Polish Americans participate in some sort of Polish ethnic activity, with polka music and dancing a very frequent choice. As we saw in Pulaski, the lively Polish polka scene attracts dancers from other polka styles, too. They eagerly show up at Polka Days and other Polish polka festivals to dance to the

Polish-style bands. While some polka scenes are sinking, the Polish American polka may turn out to be the life boat.

And finally, it is impossible to overlook polka's massive popularity among newer immigrants to the Midwest: Latinos, especially Mexicans. Much of the Mexican repertoire is in polka and waltz rhythm. It is a very big business. The most popular bands sell millions of recordings, making frequent appearances on Spanish-language television channels and, recently, YouTube. Music videos by the most popular bands have been viewed online multiple millions of times.

More than a century ago, the polka represented a tradition binding together European immigrants to the United States in cultural communities. It is fitting, and a testimony to the culturally cohesive power of this venerable dance and its music, that still today the polka is serving the same purpose among recent immigrants who have arrived to enrich our society with their presence and culture.

Moreover, there remain active cadres of polka lovers among Americans whose families have been in the United States for generations. Though smaller in numbers than in the polka's heyday, people with a passion for polka have a way of finding one another, online and in person. And although regular polka radio broadcasts have become scarce, today's fans can listen to the music around the clock via the Internet Radio networks 24/7 Polka Heaven and Polka Jammer. Satellite and cable TV feature polka shows like Molly Busta's *Polka Party* on RFD-TV and *Funtime Polka* on western Minnesota's Pioneer Public Television network. What's more, videos of recent and decades-old polka TV shows can be found online along with countless amateur videos recorded at polka dances. With the support of modern communications media, a smaller but active and lively polka scene will persist. There will be new generations of devoted polka fans, dancers, and musicians.

People still need the warmth and human contact from belonging to a cohesive community. The decision to participate in the activities of the polka network may be an individual choice—an idiosyncratic interest that might become a consuming passion. Or polka passion may derive from family tradition. While many children of polka-loving families reject the dance and music in favor of more popular genres, there are many others who find the world of polka irresistible. The vast number of multigenerational polka musician families attests to the sustained power of polka exuberance. The heady rush of whirling across a dance floor, tuned in to your partner's every move, in time with the joyous and exhilarating music of a really good band, produces the blissful high known as polka happiness. In an often troubled and difficult world, the chance to experience such moments of unbridled joy will continue to attract devotees to the polka.

ACKNOWLEDGMENTS

got into polka music by chance and by design. It was a much different world than the world of high art I had grown up in (my mother was an actress, my father a painter, and my step-father a theater director). Although I inevitably joined the family business of making experimental work, I also developed a fascination with another kind of art—in particular, the moments when "ordinary" people gathered to perform and play: in a gospel church, at a Romani wedding, amidst a Dionysian carnival, and of course at a polka dance.

This was why my ears perked up one day in the early 1970s, when a colleague at SUNY Buffalo, ethnomusicologist Charles Keil, quoted the great black jazz musician, Charles Mingus—"White Man, go study the polka!"—and vowed he was going to write a book on the subject. A few weeks later, when Charlie came back from a dance and told me what he'd seen, I was immediately taken with the idea of studying the polka myself.

The next time he went, I tagged along and brought my camera.

Last year, some twenty years after *Polka Happiness* was published, and forty years after that first encounter, my camera and I found ourselves once again at a polka dance. This time the dance was in Wisconsin. Although I had shot in and around Milwaukee, I'd never really explored this state's other polka scenes. Luckily, I had Richard March to guide me. With his granular knowledge of Wisconsin's polka people, polka styles, and polka places, Rick made it easy for me to re-engage. This book is the record of our journeys; I thank Rick for the opportunity.

I had another guide as well. I am particularly grateful to Tom Bamberger, my "Photoshop guy." Along with a dazzling set of technical skills, Tom brought an artist's eye and a curator's brain to the task of editing the images for *Polka Heartland*. Tom's been helping me like this for a very long time. He's played a major role in five of my books. Let me now say in print what I tell him every day.

Thank you and thank you again, Mr. Bamberger!

—Dick Blau

give my sincere thanks to Kathy Borkowski and Kate Thompson at the Wisconsin Historical Society Press for encouraging me to undertake this book. And to Carrie Kilman for her able editing and prodding to have me improve it. Thanks to co-author Dick Blau for offering his awesome photographic skills and sharp insights to the undertaking. Thanks to Jim Leary for being my longtime fellow traveler in discovering, discussing, and analyzing the world of upper midwestern polka. Thanks to the staff of the University of Wisconsin's Mills Music Library, especially Jeanette Casey, Tom Caw, and Matt Appleby for their help in using their archive, which has the finest collection of Midwestern polka music in the world. Thanks to Greg Drust, polka media person and community scholar, for sharing his deep knowledge with me.

When it comes to further acknowledgments, I'm afraid to attempt to list all the names of the polka musicians from Wisconsin and neighboring states who have contributed so greatly to my knowledge of the idiom. The list would be much too long and inevitably I would forget to include some of the important names. The same goes for the dancers, festival organizers, media people, and other polka music enthusiasts. But you know who you are! My sincere thanks to you all.

—Rick March

Rick March playing his button accordion at the Polish Center of Wisconsin in Franklin, ca. 2007, in a photo taken by Dick Blau

SELECTED READINGS AND RECORDINGS

BOOKS

Bohlman, Philip V., and Otto Holzapfel. *Land without Nightingales: Music in the Making of German-America.* Madison: University of Wisconsin Press, 2002.

Dolgan, Bob. *America's Polka King: The Real Story of Frankie Yankovic and His Music.* Cleveland: Gray and Co., 2006.

Greene, Victor. *A Passion for Polka: Old-Time Ethnic Music in America.* Berkeley: University of California Press, 1992.

Keil, Charles, Angeliki V. Keil, and Dick Blau. *Polka Happiness.* Philadelphia: Temple University Press, 1992.

Leary, James P. *Polkabilly: How the Goose Island Ramblers Redefined American Folk Music.* New York: Oxford University Press, 2006.

Leary, James P. *Yodeling in Dairyland.* Mount Horeb, WI: Wisconsin Folk Museum, 1991.

Leary, James P., and Richard March. *Down Home Dairyland: A Listener's Guide.* Madison: University of Wisconsin–Extension, 1996.

Nusbaum, Philip. *Norwegian-American Music from Minnesota: Old-Time and Traditional Favorites.* St. Paul: Minnesota Historical Society Press, 1989.

Peña, Manuel. *The Texas-Mexican Conjunto: History of a Working Class Music.* Austin: University of Texas Press, 1985.

Rippley, LaVern J. *The Chemnitzer Concertina: A History and an Accolade.* Northfield, MN: St. Olaf College Press, 2006.

Titon, Jeff Todd, and Bob Carlin, eds. *American Musical Traditions.* Vol. 4, *European American Music.* New York: Shirmer Reference, 2002.

ARTICLES

Leary, James P., and Richard March. "Dutchman Bands: Genre, Ethnicity and Pluralism." In *Creative Ethnicity: Symbols and Strategies of Contemporary Ethnic Life,* edited by Stephen Stern and John Allan Cicala, 21–43. Logan: Utah State University Press, 1991.

Lornell, Kip. "The Early Career of Whoopee John Wilfahrt." *John Edwards Memorial Foundation Quarterly* 21, no. 75–76 (1989): 51–53.

March, Richard. "Polka and Tamburitza: Ethnic Music and Dance Traditions in the Upper Midwest." In *Ethnic and Border Music: A Regional Exploration,* edited by Norm Cohen, 139–170. Westport, CT: Greenwood Press, 2007.

March, Richard. "Slovenian Polka Music: Tradition and Transition." *John Edwards Memorial Foundation Quarterly* 21, no. 75–76 (1989): 47–50.

RECORDINGS

"60th Anniversary Greatest Hits," Frankie Yankovic, Polka Connection. Originally released 1997.

"Ay te Dejo en San Antonio," Flaco Jimenez, Arhoolie 318. Originally released 1979.

"Deep Polka: Dance Music from the Midwest," Smithsonian Folkways Recordings, SFW 40088. Originally released 1998.

"Deeper Polka: More Dance Music from the Midwest," Smithsonian Folkways Recordings, SFW 40140. Originally released 2002.

"Golden Horns on Green Fields," Polkaland Recordings, CD639. Originally released 2003.

"Is Everybody Happy?" Karl and the Country Dutchmen, self-produced CD. Originally released 1994.

"Jammin' Polkas," Steve Meisner. Originally released 1988.

"Music Music Music," Eddie Blazonczyk's Versatones, Bel-Aire BACD 3050. Originally released 1996.

"Narciso Martinez: Father of the Texas-Mexican Conjunto," Narciso Martinez, Arhoolie CD-361. Originally released 1993.

"Nowe Wesołe Piosenki Ludowe," Li'l Wally, Jay Jay Records 5057. Originally released 1960.

"Recorded 1935–36," Romy Gosz & his Orchestra, Polkaland CD-602. Originally released 1997.

"Whoopee John, Volume 2," Polka Connection. Originally released 1994.

NOTES

1. Gordon Hartmann, "Polka Friendzy," HG Studio HG-5057, 1990.

2. *Kentish Gazette,* August 13, 1844, p. 2.

3. Arizona Experience, "Music without Borders: Waila, Mariachi, and Tejano Music," http://arizonaexperience.org/people/music-without-borders.

4. Dorothy Tamburini and Ruth Ruling, "Polka Sa Nayon," Folk Dance Federation Research Committee, www.folkdance.com/LDNotations/PolkaSaNayon1960LD.pdf.

5. "Polka," Oxford English Dictionary, www.oed.com.

6. Charles Keil, Angeliki V. Keil, and Dick Blau, *Polka Happiness* (Philadelphia: Temple University Press, 1992), 10–14.

7. Jake Fuller, "Polka—History of Dance," http://www.centralhome.com/ballroomcountry/polka.htm; "The Polka," *Independent Lens,* PBS, www.pbs.org/independentlens/polkatime/polka.html; Maja Trochimczyk, "Polka," Polish Music Center, University of Southern California, www.usc.edu/dept/polish_music/dance/polka.html.

8. Čeněk Zíbrt, "Jak se kdy v Čechách tancovalo: dějiny tance v Čechách, na Moravě, ve Slezsku a na Slovensku z věků nejstarších až do nové doby se zvláštním zřetelem k dějinám tance vůbec,"[How and where dancing was done in the Czech lands: History of dance in Bohemia, Moravia, Silesia and Slovakia from the oldest ages to the new era with consideration of the history of dance in general] Prague, 1895, p. 339–340.

9. Robert W. Gutman, *Mozart: A Cultural Biography* (New York: Mariner Books, 2000).

10. Joseph Wechsberg, *The Waltz Emperors: The Life and Times and Music of the Strauss Family* (Liverpool: Putnam, 1973), 59–61.

11. George Gordon Lord Byron, "Waltz," in *The Works of Lord Byron,* vol. 5 (Philadelphia: R.W. Pomeroy, 1832), 289.

12. *The Mouton Bay Courier,* October 1, 1853 (from *Blackwoods Magazine,* Brisbane, Queensland), 4.

13. Ibid.

14. Ibid.

15. Keil, Keil, and Blau, *Polka Happiness,* 10–11; Zíbrt, "Jak se kdy v Čechách tancovalo."

16. "French Plays," *London Standard,* June 3, 1844, p. 2.

17. *Ayr Advertiser,* July 18, 1844, p. 3.

18. *Leicestershire Mercury,* September 28, 1844, p. 2.

19. "On the Degrading and Immoral Tendency of the Polka Dance," *Manchester Courier,* September 22, 1847, p. 8.

20. "Dickens and His Children: A Loving Description by Miss Mamie Dickens, His Daughter," *The New York Times,* March 17, 1884, p. 2.

21. "The Best of the Pictorials," *New York Daily Tribune,* May 2, 1844, p. 3.

22. "Music from Atwill's," *New York Daily Tribune,* June 4, 1844, p. 1.

23. "The Polka," *New York Daily Tribune,* June 10, 1844, p. 2.

24. Advertisement, *New York Daily Tribune,* June 19, 1844, p. 3.

25. *New York Daily Tribune,* July 27, 1845, p. 2.

26. *New York Daily Tribune,* September 22, 1846, p. 1.

27. "Fashionable Dancing," *Lewisburg Chronicle,* October 22, 1851, p. 1.

28. "Battery Wagner Polka-Mazurka," sheet music, Library of Congress, http://www .loc.gov/item/ihas.200000637/.

29. US Bureau of the Census, *Historical Statistics of the United States, Colonial Times to 1970,* Bicentennial Edition (Washington, DC: Government Printing Office, 1975).

30. Letter to the Editor, *Chicago Times,* May 22, 1858, p. 3.

31. Ibid.

32. James P. Leary and Richard March, *Down Home Dairyland: A Listener's Guide* (Madison: University of Wisconsin–Extension, 1996), 121–124.

33. Leon Kochnitzky, *Adolphe Sax and His Saxophone* (New York: Belgian Government Information Center, 1964), 3.

34. Victor Greene, *A Passion for Polka: Old-Time Ethnic Music in America* (Berkeley: University of California Press, 1992), 49–53.

35. Robert Janda, "Entertainment Tonight: An Account of Bands in Manitowoc County Since 1910," Occupational Monographs, no. 28 (Manitowoc, WI: Manitowoc County Historical Society, 1976).

36. Greene, *A Passion for Polka,* 219.

37. Francis McMahan, personal communication, 1985.

38. Pulaski History, Pulaski Area Historical Society, http://www.pulaskiwihistory.com/ pulaskihistory/index.html.

39. Trevor Jenson, "Walter 'Li'l Wally' Jagiello: 1930–2006," *Chicago Tribune,* August 23, 2006.

40. Ben Sisario, "Eddie Blazonczyk, 70, Polka Singer and Bandleader, Dies," *The New York Times,* May 24, 2012.

41. Lojze Slak obituary (in Slovene), http://www.rtvslo.si/kultura/glasba/ umrl-je-narodno-zabavni-glasbenik-lojze-slak/267295.

42. Bob Dolgan, *America's Polka King: The Real Story of Frankie Yankovic and His Music* (Cleveland: Gray and Co., 2006).

43. Ibid.

44. Ibid.

45. "La Historia detrás del Mito de Horóscopos de Durango," El Trece, http://www.eltrece.mx/capitulos/lahistoriadetrasdelmito/166578/ la-historia-detras-del-mito-de-horoscopos-de-durango.

46. H. Nelson Goodson, "Female Lead Singers from Los Horoscopos de Durango Arrested in Florida," Hispanic News Network USA, November 12, 2012, http://hispanicnewsnetwork.blogspot.com/2012/11/female- lead-singers-from-los-horoscopos.html; H. Nelson Goodson, "Terrazas Sisters Get Probation for Altercation with Okeechobee Sheriff Deputies," Hispanic News Network USA, February 21, 2013, http://hngwiusa.wordpress.com/ 2013/02/21/terrazas-sisters-get-probation-for-altercation-with-okeechobee- sheriff-deputies/.

INDEX

O. 2/16
B 8/16
W 3/17
H 10/17